LKA

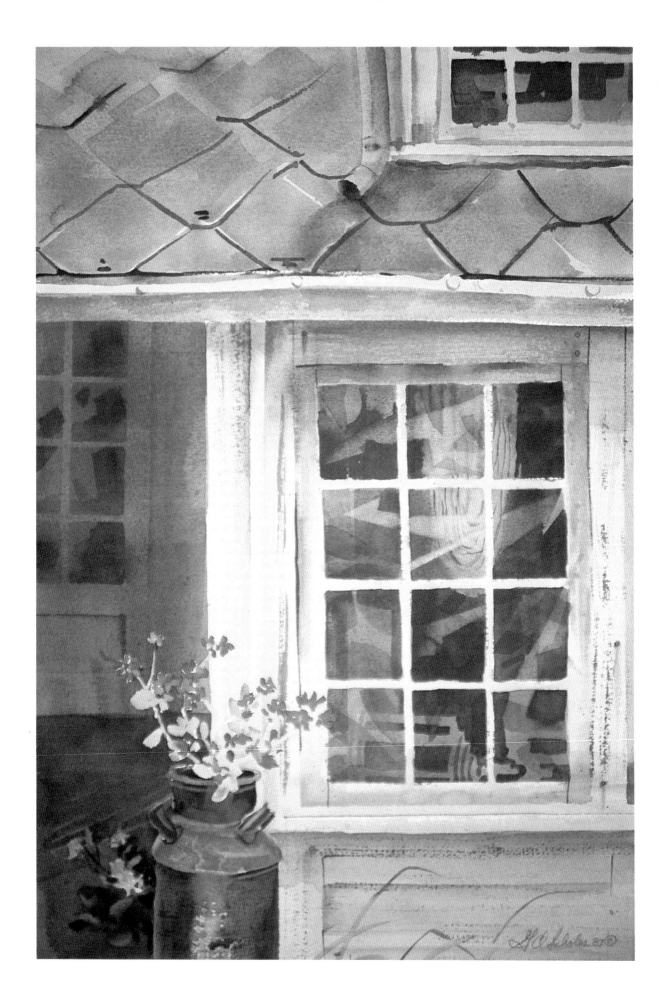

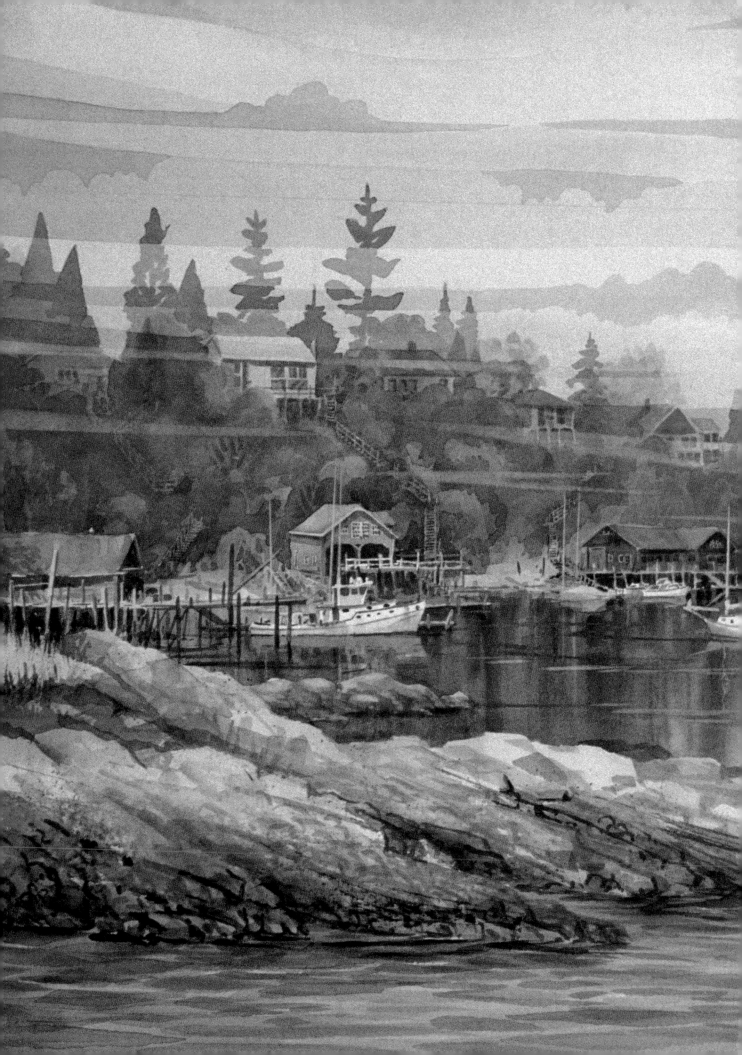

WATERCOLOR AND HOW

Graham Scholes

WATSON-GUPTILL PUBLICATIONS/NEW YORK

Half-title page:
WEAVER'S WINDOW
22" × 15" (55.9 cm × 38.1 cm),
Arches 300-lb. cold-pressed paper

Title page:
DEEP COVE
22" × 30" (55.9 cm × 76.2 cm),
Arches 300-lb. cold-pressed paper

It all started with Mr. Fred Fraser, the art teacher who ignited my desire to paint with watercolors. To you, Fred, I am eternally grateful.

My sincere thanks to Jean Brouillet of Reader's Digest, Montreal, and to Nelson Doucet of General Publishing, Toronto, whose initiative and encouragement caused this book to be published.

Thanks also go to Mary Suffudy, Executive Editor at Watson-Guptill; Marian Appellof, my editor; and Areta Buk, my designer, for guiding me through the new venture of book publishing. Their help and understanding made it a creative and rewarding experience.

Edited by Marian Appellof
Graphic production by Hector Campbell
Text set in 11-point Clearface

First published in 1989 in New York by Watson-Guptill Publications,
a division of Billboard Publications, Inc.,
1515 Broadway, New York, N.Y. 10036

Library of Congress Cataloging-in-Publication Data

Scholes, Graham.
 Watercolor and how.

 Bibliography: p.
 Includes index.
 1. Watercolor painting—Technique. I. Title.
ND2420.S38 1989 751.42'2 88-28033
ISBN 0-8230-5656-2

Distributed in the United Kingdom by Phaidon Press Ltd.,
Musterlin House, Jordan Hill Road, Oxford OX2 8DP

Manufactured in Japan

First printing, 1989

4 5 6 7 8 9 10 / 94 93 92

This book is dedicated to my wife and partner, Marnie, and to our three children, Doug, Jay, and Sue Ellen, for their understanding and sacrifice during the past twelve years and for enabling me to satisfy an inner desire to paint in transparent watercolors.

I also wish to dedicate it to the artists who believe, as I do, in transparent watercolors. Working in watercolor as a transparent medium precludes the use of opaque pigments. The whites in a painting must be white paper; this is what demands tremendous skill and makes the challenge greater than painting in gouache or other opaque pigments like oils or acrylics.

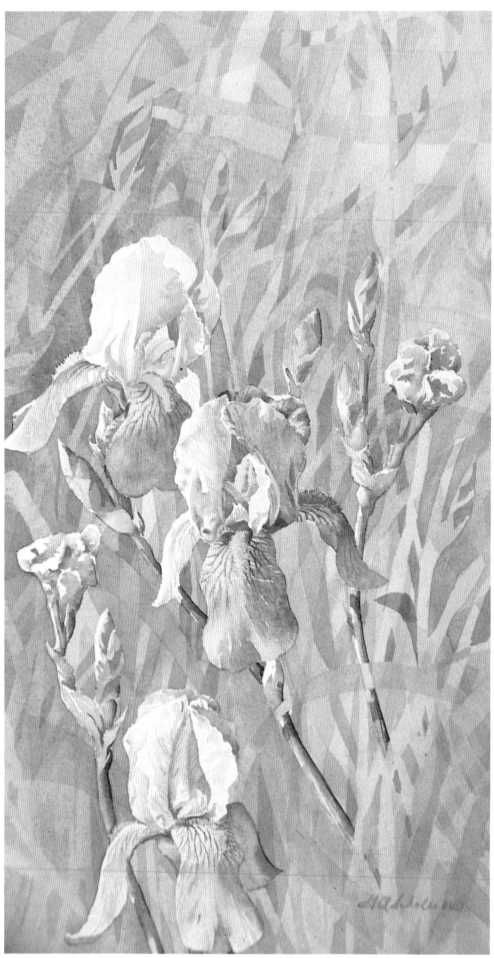

DUSTY IRIS, 22″ × 12″ (55.9 cm × 30.5 cm), Arches 300-lb. cold-pressed paper

CONTENTS

Introduction 9

MATERIALS
On-Location Equipment 12

Brushes 14

Other Painting Tools 18

Paints 22

Paper 30

Using Photography 32

BASIC COMPOSITION
Observing Nature 36

Composition 38

Perspective 44

Sketching 46

TECHNIQUES
Controlling the Medium 54

Pyramid of Washes 58

Masking for Texture 60

Masking in Landscapes 64

Painting in Sections 66

Staining Techniques 70

Nonstaining Techniques 76

Sepia Step-by-Step 84

Wash-Offs 90

Painting Reflections 98

Painting Moving Water 100

NEGATIVES
Seeing Negative Shapes 112

Painting Negative Shapes 118

Negatives with Multicolor 122

STYLE
Arriving at Your Own Style 128

My Style of Work 130

Developing a Theme 132

Broadening Your Horizons 138

Select Bibliography 142

Index 143

PREFACE

This book is due in part to the numerous students who have attended my watercolor workshops over the past ten years. The many questions and problems they have posed in aiming to achieve skill and ability have enabled me to understand their needs and offer some answers here.

Much of what I teach has been a gift from someone else, so I'm simply passing this gift on. I feel that each person has potential that will emerge if he or she is willing to work hard. It is my philosophy that the better the students get, the better I had better get. Having worked for twenty-odd years in the packaging industry, where competition is an important factor in coming up with creative and innovative ideas, I realized that competition in painting as well is an important factor for my growth and improvement. I hope it works that way for you.

This book fills a need for the beginner and the leisure-time artist, yet offers information that will be of interest to the advanced artist as well. Anyone who wants to know more about transparent watercolor for pleasure and better appreciation will benefit. I will take the reader through a ten-year span of my development, highlighting numerous techniques and skills; statements of philosophy throughout the book will help you reach new skill plateaus as you progress in your painting career.

Caricature by Dan Crimmins, Montreal

INTRODUCTION

An old Arabian proverb states, "Seeing is not a mechanical process." All of us have the ability to see, but do we *look*, really *look?* Do we take the time to analyze a subject and make comparisons between one form and the next, one value and the next, or one line and the next? Betty Edwards phrased it beautifully in *Drawing on the Right Side of the Brain:* "Draw what you see, not what you think you see." I like to express it by saying, "If you can't see it, you can't paint it." We have to learn to see; like speaking and writing, seeing is an acquired art. And if it can be acquired, then practice must be the answer to achieving this important skill plateau.

"The eye is blind to what the mind does not see" is an expression that takes us one step further in our development. A mind can be likened to a computer: The more you put in, the more can be retrieved. A computer can be effective and useful only if it is first fed or programmed with facts and data. The programming of the mind is clearly up to the programmer—*you.* The more you program your mind with art and skill-related information (facts and data), the more you will enjoy painting and get satisfying results. It boils down to "What you put in is what you get out"—with the following exceptions: soul, emotion, and creativity. Achieving competence with transparent watercolor depends on how much you are willing to practice. Success does not occur simply by acquiring information. You must put it to work.

What is an artist? The painter Howard Pyle (1853–1911) once said that people are not artists by virtue of clever technique or brilliant methods, but in the degree to which "they are able to sense and appreciate the significance of life that surrounds them, and to express that significance to others."

Art is a language; the habitual use of it will enable you to express ideas and thoughts. The question I'm asked most often is, "How long does it take to master watercolors?" I don't think you ever truly master them, but you can become proficient in the medium. So my response is, "It's not how long, but how many." It somehow comes down to a "numbers game." The number of paintings and

exercises you need to do to achieve proficiency depends on the individual. Some people are more observant and comprehend more quickly than others; a genius may require as few as 100 exercises over the course of a week, a month, or a year, while other people, like me, may need to do 1,000 during that same period. The more you do, the better you get. Practice enables you to develop soul, emotion, and creativity, which come from within. Nothing comes from within unless it can find a way out . . . so get working.

I use the word "exercise" rather than "painting" to encourage positive vibes before and after a painting session. When you start a painting and are faced with that lovely piece of white watercolor paper, intimidation and even fear can set in. You may be hesitant to touch a brush to the paper. The painting, which in the mind's eye is going to be a masterpiece, could be spoiled or not up to expectations. Working under the psychological thought of failure sure can take the fun out of the sport. The way to avoid this is to approach your painting as an exercise that will help you attain a new skill plateau with every session. If the exercise is a failure with numerous mistakes, that's fine; it wasn't intended to be a masterpiece, and much can be learned from the mistakes. After all, a mistake is simply evidence of an attempt to accomplish something. If the exercise ends up so-so—*comme si, comme ça*—with good and bad sections, it was an important learning experience. Should the exercise turn out to be a masterpiece . . . wow, tickity boo!! That's "the fun part of the fun"—an expression my son Jay used when he was six years old. You'll end your sessions in a positive frame of mind, with a sense of achievement instead of disappointment. Even when you suppress some of your inner competitive spirit, it will prevail and drive you toward higher goals with every exercise.

Watercolor is elusive and intriguing, and mastering the tremendous variety of techniques to reach higher and higher skill plateaus will take me the rest of my life. It will take even longer to satisfy my curiosity for this fascinating medium.

MATERIALS
My Buddies

In this chapter I introduce the basic materials you will need to get started in watercolor painting—brushes, pigments, paper, and the like—as well as many other tools you will want to consider. Some of these you will find naturally suited to your personality and skills, others may require lots of practice, and still others may not suit you at all and will be discarded as you grow and reach different skill plateaus. As an artist you should continually experiment with a variety of materials and subjects that will allow your personality to express itself and help you develop a style.

ON-LOCATION EQUIPMENT

Painting on location means having portable equipment that is light and compact enough to carry anywhere. I used a knee easel and folding chair for numerous years but always found sitting to be a restrictive position for painting. It is an economical easel, however, and you can make one yourself as illustrated. I call it "Kneasel-Mate." The design was given to me by Fred Fraser, my art teacher at Western Technical School in Toronto. I remember him not only for this easel but also for the sketching trips we made together to back alleys, and for his thrifty and practical outlook. Most important, he was instrumental in encouraging my keen interest in watercolor.

I prefer the freedom of standing while painting on location and like to have all my materials and tools in the same position as in my studio. I use an easel that is called an Easel-Mate, which fulfills my needs and comforts. The Easel-Mate attaches to a camera tripod, which is adjustable on any terrain. With its tilting working surface it is convenient for standing or sitting, and it has a place for water containers, brushes, palette, and tissue. The unit is easy to set up and, most important, light to carry. For further information write to:

> Easel-Mate
> General Delivery
> Sidney, B.C.
> Canada V8L 3S2

It's common knowledge that it is easier to carry two buckets of water than one. For a balanced load I carry my easel in one hand, and in the other a canvas bag that holds the rest of my equipment: a two-liter jug of water, brush holder (a rolled-up bamboo place mat), box of tissues, roll of paper towels, watercolor paper (protected in a corrugated folder), and sun hat. A small box holds such miscellaneous items as a razor blade, sponge, extra pigments, eraser, and whatever else you may need while on location. Don't overdo it, or you will need a truck to carry the bag!

On the arm of a lawn chair you can rig a plastic container to use as a handy water container. One on each arm is good for lots of clean water. A small folding TV table is light enough to carry easily and makes a convenient place for tissue, brushes, palette, and so on.

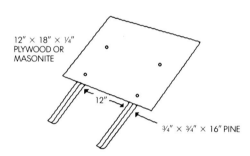

12″ × 18″ × ¼″ PLYWOOD OR MASONITE

12″

¾″ × ¾″ × 16″ PINE

Mount your watercolor paper on a separate board and rest the board against the Kneasel-Mate. You can adjust the slant of the easel by moving your legs and feet back and forth.

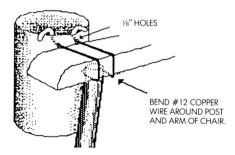

⅛″ HOLES

BEND #12 COPPER WIRE AROUND POST AND ARM OF CHAIR.

With a red-hot piece of wire burn two ⅛″ holes an inch apart just below the rim of a rigid plastic container of about two-cup capacity. (You can use a piece of coat-hanger wire for this; hold it with pliers and heat it over the burner of a stove or an open flame.) To attach the container to the chair, use a length of #12 copper electrical wire, leaving the plastic coating on it.

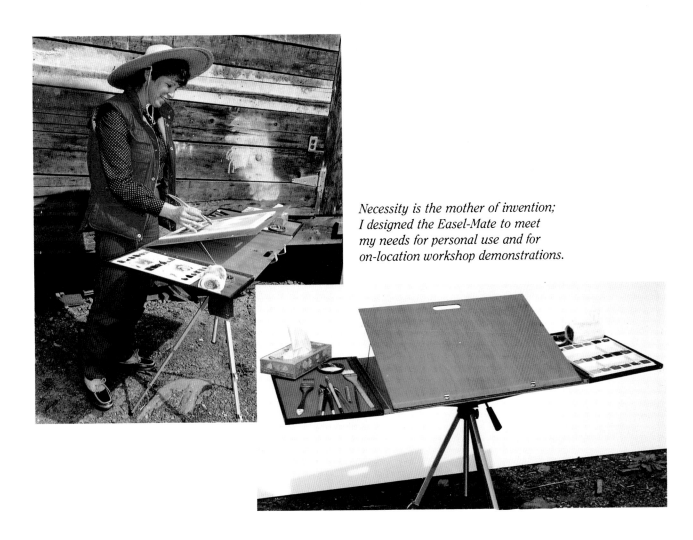

Necessity is the mother of invention; I designed the Easel-Mate to meet my needs for personal use and for on-location workshop demonstrations.

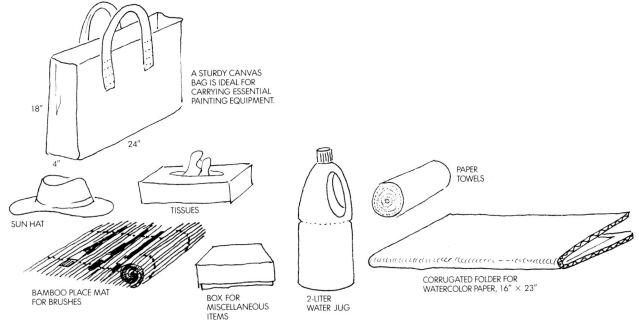

18"

24"

4"

A STURDY CANVAS BAG IS IDEAL FOR CARRYING ESSENTIAL PAINTING EQUIPMENT.

SUN HAT

TISSUES

PAPER TOWELS

BAMBOO PLACE MAT FOR BRUSHES

BOX FOR MISCELLANEOUS ITEMS

2-LITER WATER JUG

CORRUGATED FOLDER FOR WATERCOLOR PAPER, 16" × 23"

BRUSHES
MEET MY HAIRY FRIENDS

Like people, brushes come in all shapes and sizes. And, just as people with certain characteristics will become your friends, so too will your paintbrushes. Through use, you will adopt those that best suit your personality.

The important consideration for choosing brushes is that they have good resilience. This rules out those made from squirrel or camel hair, as they go very limp and soft when wet. As for size, the watercolorist Eliot O'Hara said it well: "A painting can be done with large or small brushes, it doesn't matter. It just takes longer to do it with a small brush." Initially you will be inclined to use small brushes because of the control they allow, but with practice you will eventually work with larger ones. Having numerous brushes is economical, because when you want to change colors, you don't have to rinse out the brush you've just used but can simply pick up another one each time you want to apply a

new pigment. Then when you want to repeat a color, you can reuse the brush you started with. You are continually buying paints, so don't waste them for the sake of a few extra brushes.

Brushes used for watercolor exist in a range of shapes and sizes and are made of various materials. Pure sable brushes are the most expensive, and for beginners and leisure-time artists are not really necessary. However, if you need a fine-pointed round, a Winsor & Newton Series 7 is the crème de la crème sable—and a costly one—to consider. Brushes made from a combination of sable and nylon are less expensive than pure sable and offer reasonable quality for the price. Ox hair, hog hair, and nylon make the least expensive brushes, and each type of fiber has its own traits. Keeping economics and value in mind, I look for the following characteristics in the brushes that will enable me to achieve various techniques.

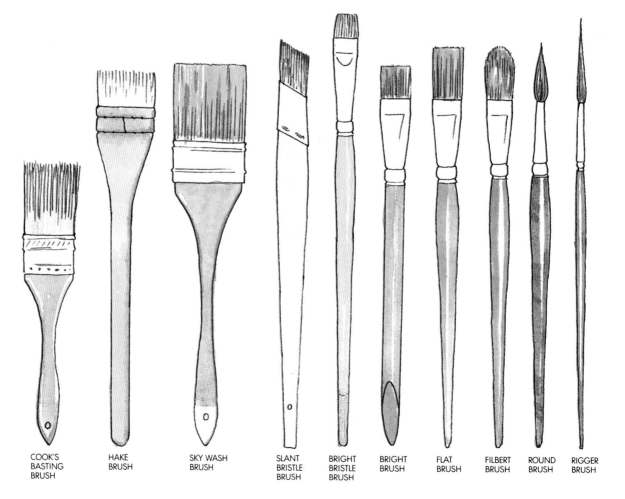

COOK'S BASTING BRUSH | HAKE BRUSH | SKY WASH BRUSH | SLANT BRISTLE BRUSH | BRIGHT BRISTLE BRUSH | BRIGHT BRUSH | FLAT BRUSH | FILBERT BRUSH | ROUND BRUSH | RIGGER BRUSH

HAKE BRUSH. The Japanese *hake* (pronounced "hockey") is a flat brush made of goat hair. Although it has only fair resilience, it creates interesting drybrush results and is most useful for rewetting a painted area. The hake is very soft and will not disturb a dry, light- or medium-value wash. Available in 1″ to 4″ widths, a 1″ to 2″ size should suit most needs.

SKY WASH BRUSH. This brush is used for putting down washes over large areas. The wash can be either juicy and flowing, or controlled for wet-in-wet sections. I recommend one made of nylon in the 1½″ or 2″ size. The sky wash brush offers much more control than a hake when you work wet-in-wet.

COOK'S BASTING BRUSH. Recently I picked up 1½″ and 2″ natural bristle Taiwan specials at $1.50 apiece. What lovely brushes! Don't tell the manufacturers artists are using them, or the price will skyrocket! Look for those made of natural bristle; they give great drybrush effects. These have to be one of the best buys around.

FLAT BRUSH. This square brush comes in sizes from ⅛″ to 1″. It is generally used to render buildings and mechanical subjects. I recommend one made of nylon. In my own work I prefer the somewhat shorter bright shape as an alternative.

BRIGHT BRUSH. For this brush nylon is fine; it's shorter than a standard flat and is available in widths from ⅛″ to 1″. Some manufacturers indicate size with numbers from 1 to 12. My recommendation is to start with the ½″ size and eventually move up to ¾″ and 1″ as you progress in ability and painting size. Because this brush is slim, it holds less moisture and results in better control of wet-in-wet techniques. Use a ⅛″ size to render bricks on a building.

BRIGHT BRISTLE BRUSH. Common in oil painting, a bright made of hog hair is indispensable in watercolor. Purchase the finest quality you can find, as this brush takes a lot of abuse when you use it to scrub color off a painting. It comes in sizes 1 through 12; a #6 (about ½″ wide) is the most useful.

Sketch painted using a 1½″ sky wash brush, upper left; and a 1½″ hake, right.

Sketch painted with ½″ and ¾″ filbert brushes and a #8 round.

FILBERT BRUSH. A filbert is a versatile, almost oval-shaped brush for rendering nonmechanical shapes in paintings. Filberts range in size from ½″ to 1″; I suggest the ¾″ size. Nylon bristles should suit most artists' needs.

SLANT BRISTLE BRUSH. A slanted 1″ brush made of hog hair is another implement you'll want to consider. Its stiffness enables you to pick up a lot of pigment and paint strong areas of color in a single wash. The slant feature allows you to work in small areas, where the brush's edge is effective for rendering medium detail. This brush is also good for the wet-in-wet technique, as well as for spattering and drybrush work.

ROUND BRUSH. I like the sable-and-nylon combination for this type of brush, although ox hair is more economical and also works well. Rounds made of nylon alone lose their point after repeated use. Sizes range from #000, the smallest, to #14, the biggest; sizes 4 and 8 are especially useful. Rounds are used for small detail work and applying masking fluid.

RIGGER BRUSH. Sometimes called a script brush, the rigger is good for rendering details like wire, branches, and twigs. These brushes are available in sable, ox hair, or nylon, in sizes 0 to 6; the choice of material makes little difference in performance. I recommend the #5 size.

HOLDING YOUR BRUSHES
Different Strokes for Different Folks

There aren't too many ways to grasp a pen or pencil for writing. But a paintbrush can produce many different effects according to how it is held and manipulated on the paper. The series of stop-action photographs illustrates a few ways to achieve specific results.

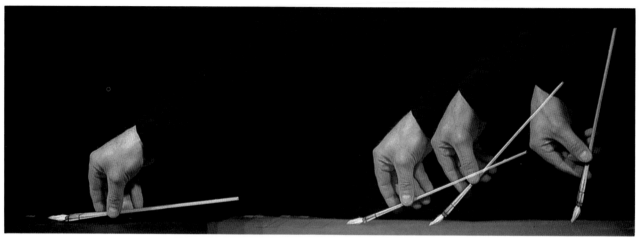

For drybrush effects, hold a moderately loaded hake brush flat and use the heel. Moving from left to right as illustrated, the more you swing the brush vertically, the more the pigment flows, until a solid layer of paint occurs.

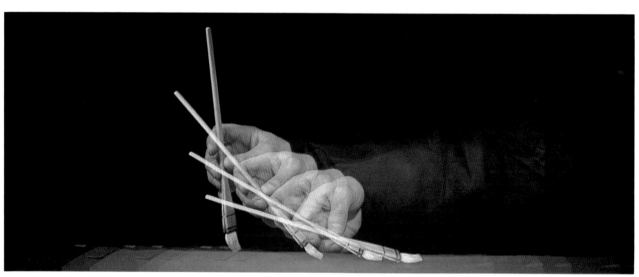

Holding the brush as illustrated here but moving right to left brings similar results.

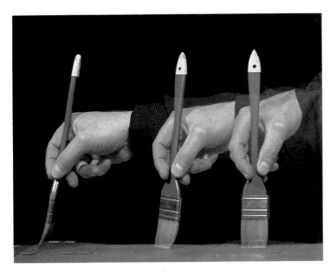

When using a flat brush, you can control the width of each stroke by rolling the brush in your fingers as you draw it across the paper. Notice the position of the thumb and forefinger, where the broad stroke is started, and at the finish, where the stroke is thin. Pulling the brush flat across the paper makes a wide stroke; turning it so that the narrowest part is angled toward you causes the brushstroke to get narrower.

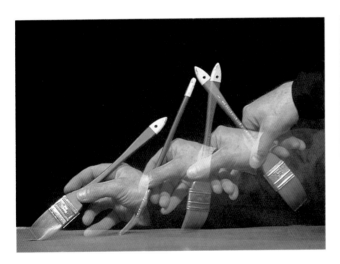

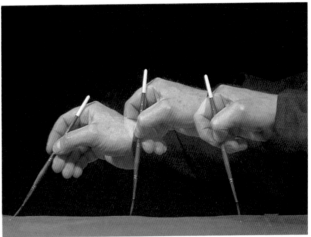

A petal-shaped stroke is achieved with more wrist action. Hold the brush firmly in your fingers and, toward the end of the stroke, twist the brush and lift it off the paper to give the petal its pointed tip. (In the photograph the action has been spaced to better illustrate the motion of the hand.)

Round and rigger brushes are held well up on the handle for a looser type of stroke. A combination of finger and arm action is employed, depending on the stroke length you need.

OTHER PAINTING TOOLS
HAIRLESS FRIENDS

Mastering the use of other painting tools and materials greatly expands the variety of watercolor techniques you can pursue, and experimentation with all sorts of implements keeps things intriguing as you work. Just be careful not to allow the use of any one tool to become too obvious in your painting, since this may cause it to look gimmicky.

POLY BRUSH. A foam brush of synthetic sponge is great for wetting paper; I use a 2″ size. You can purchase one in any hardware store for under $1.00. Don't use a poly foam brush for rewetting a painted area, as its firmness and texture will remove pigment (use your hake brush instead). It's good for washing pigment off a dry painting in the wash-off technique described later in this book.

INKLESS BALL-POINT PEN. A dry pen—that is, one without ink so it won't write—makes a good tool for drawing into wet washes. Any drawing done in this manner cannot be removed, as it slightly ruptures the surface of the damp paper and the nearby pigment is absorbed, causing a dark line. An empty ball-point pen is also good for "debossing"— impressing negative lines—in pencil sketches.

PAINTING KNIFE. The watercolor painter Zoltan Szabo describes and illustrates the use of a painting knife beautifully in his books (which are worth having in your library). Using a grindstone, I change the shape of a 1″ size knife to give it more shoulder and a finer

tip, which makes this implement easier to work with. Smooth the edges of a new knife on fine sandpaper to prevent the tool from scratching your damp watercolor paper. Clean it with toothpaste to remove all oil so the pigment will flow on the blade and not bead up. Use a painting knife to render twigs, branches, and so on in negative or positive forms.

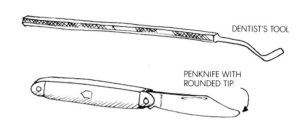

MISCELLANEOUS TOOLS. Among several tools that can be used for "squeezing back" damp pigment to create a light negative line in a dark area are nail clippers, a penknife with a rounded point, and the pointed end of a brush. One of my favorites is a dentist's tool that can be angled different ways to create lines of varying thickness.

Various tools for "squeezing back" damp pigment.

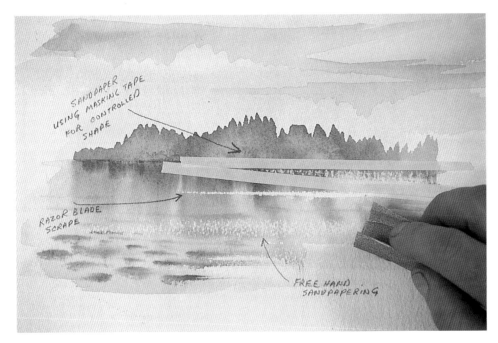

Sandpaper, masking tape, and razor blades are useful for creating a number of different effects in a water-color painting.

SANDPAPER. A medium, #120 grade works best on rough paper and fairly well on cold-pressed (medium-textured) paper when you want to create texture or recapture white highlights or the shimmer of light on water that may have gotten lost during the drybrush technique. Sand gently, and only in dried areas. If you want to apply a light glaze, the sandpapered sections will take the tint nicely.

RAZOR BLADE. With a single-edge razor blade you can scrape the surface of your paper to recapture small white highlights lost during painting.

MASKING TAPE. This is probably the most useful tool in my kit. For attaching watercolor paper to mounting board, regular household masking tape will work fine. Architectural tape is better, but I don't think it warrants the extra money. For masking sections in a painting, regular household masking tape is all I ever use. The 1″ width is best; if I want it narrower, I cut it in half with a razor blade. Use masking tape only on papers that will not tear, as explained in the section on paper, and be sure the surface is bone dry before you apply it. When applying washes over masked areas, make certain your brush is only moderately wet; a juicy wash will wick under the tape edge and result in a ragged, not a defined, line. (You can use a liquid latex mask along the tape edges to prevent this.)

WHITE PLASTIC ERASER. Staedtler is the brand I use; with it you can erase pencil lines in a section of a painting where there are light washes. Make sure the painting is completely dry first. You can also use this type of eraser to recapture a white highlight: Wet the shape required with a small brush, dry it immediately with a tissue, and erase the area. The pigment that was moistened will be removed, leaving a lovely white highlight.

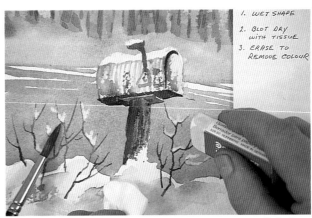

A white plastic eraser makes it easy to remove slightly damp color from a painting when you want to create white highlights.

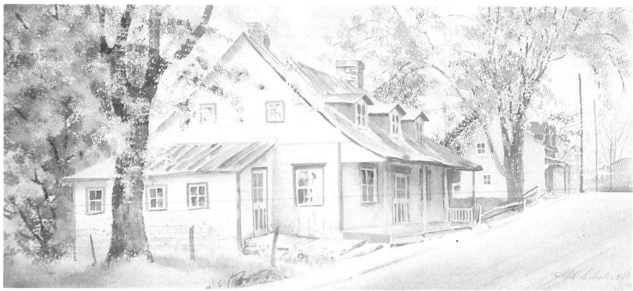

The tree trunks and foliage in this painting were rendered with a sponge. I cut templates of masking tape to mask the trunk shapes.

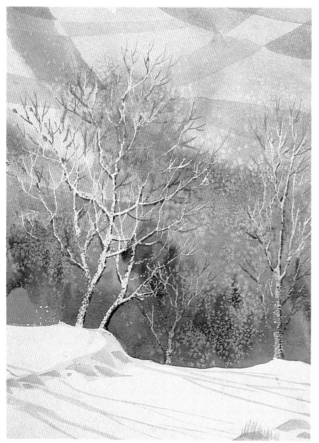

Here the trunks and large branches of the white birch trees were protected with a wax stick, while wax paper worked for the small branches. The snowflake effect was achieved with salt.

NATURAL SILK SPONGE. A sponge creates texture. Dab it into mixed pigment and apply where desired. This works especially well for depicting foliage.

TISSUE. This also allows you to achieve texture. Dab a tissue into mixed pigment and apply it to your painting, or use a rolled-up ball of dry, clean tissue on a wet wash to remove color—for white shapes of clouds, for example.

SALT. Sprinkled on a wet or damp wash, salt creates texture that can represent snowflakes or foaming, splashing water. Never use it as a crutch just to create texture in some area, though; remember, even a five-year-old can throw salt on a painting and get spectacular results. It's important to use it wisely so that the statement you make is effective.

WAX PAPER. Here is a good resist to try. Butcher's wax paper works best because it has a greater saturation of wax than the household product, but if you can't find it, rub a bar of paraffin on a piece of paper to make your own. Lay the wax paper on top of your watercolor paper and firmly draw the image you want with a pencil or scribing tool. This will transfer the wax to the watercolor paper; wax-covered areas will repel washes put over them, establishing fine negative shapes.

WAX STICK. You can draw details you wish to keep white directly on your watercolor paper with a piece of paraffin wax. You can also apply the wax over an existing color as a mask. To remove wax from an area in your painting, place a paper towel over it and apply a medium-hot iron. This will absorb the wax; repeat several times with clean paper towels to remove all traces of it. Should you want to apply a wash of color over the de-waxed area, mix a little hand soap in your pigment so the paint will cover the slight residue of wax that remains.

LATEX MASKS. Sometimes called frisket or latex resist, masking fluid is available in several brands. The best, most economical buy is Tranzmask, a brand made by Ceramichrome and used in the ceramics field. It is clear, so I add a couple of brushfuls of a nonstaining pigment (burnt sienna is good) to make it visible. To remove latex from your painting, pat it with the sticky side of masking tape. Latex can also be applied over an existing color, as illustrated in *Fiddlehead Hill*, pages 116–117. A few observations:

Exposing latex to the sun for several hours or to heat from a hair dryer can make it difficult to remove from the paper.

If masking fluid becomes thick in the jar and is difficult to apply, add water to thin it to the consistency of thick cream.

Soaping your brush before applying latex helps prevent it from clogging the brush.

After repeated use, masking fluid will clog your brush. This is easily remedied by washing the brush with a solvent such as lighter fluid—the kind you use in a Zippo lighter. I've used the same brush for latex masks for ten years. You got that right—I don't use it much!

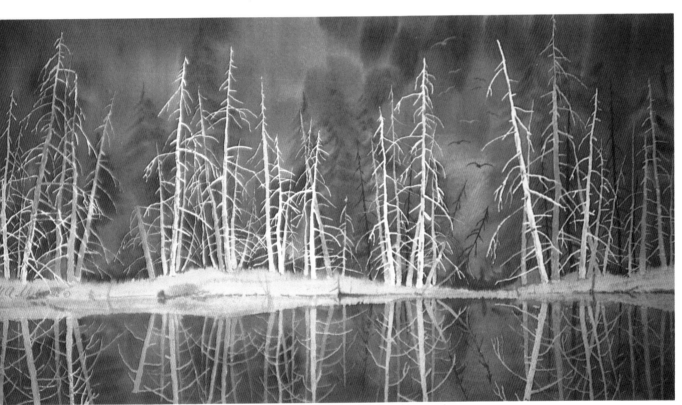

Doug Scholes, ALGOMA LACE, 12″ × 22″ (30.5 cm × 55.9 cm), Arches 300-lb. cold-pressed paper

The pattern of dead spruce trees in this painting was achieved by applying Tranzmask with a palette knife.

PAINTS
MEET MY COLORFUL PALS

You've met my other friends; now I would like to introduce you to my colors and their characteristics. My first priority when I choose pigments is that they have a high degree of permanency. I prefer the kind sold in tubes; you can squeeze whatever amount you need onto a palette and work with large brushes. The dried pan pigments have a place in the compact box you carry with you for small sketches when space and weight are factors. The other criteria I consider when deciding which paints will best suit my needs are these:

TRANSPARENCY. Pigment allows light to show through; for more luminous paintings.

STAINING. Traces of pigment remain on the paper after lift-offs; for creating highlights.

NONSTAINING. Pigment can be removed easily to achieve white highlights.

TEXTURE. Pigment's smoothness or graininess; important in achieving mood and atmosphere.

COST. Look for best value.

All hues in the chart shown opposite are Winsor & Newton Artists' Water Colours. No standardization of pigment names, quality, or colors exists among different paint manufacturers, so results will vary from brand to brand. I have rated each pigment for transparent and staining qualities using a scale of 1 to 10. S means the pigment has a smooth texture; G means it is granular.

Transparency is determined by applying a brushful of strong pigment over a black waterproof marker line. If the black line shows through clearly, the pigment is transparent, like Antwerp blue, which is rated 1 on the scale. If the pigment only partially covers the black line, it is less transparent, like new gamboge, rated 4. If the black line is covered completely, the pigment is opaque, like cerulean blue, rated 9.

Transparency has a great deal of influence on achieving luminosity in your painting. Poor-quality pigments are made with fillers, which diminish transparency and increase the chances of muddy or chalky-looking paintings. With care, you can use discreet amounts of one opaque pigment in combination with transparent ones. Mixing two opaques in a medium or dark wash will cause loss of luminosity, especially when you apply several washes one over another.

Staining is determined when you remove color that has dried. Gently scrub an area with a damp bright brush with hog-hair bristles to lift the pigment. (Note: The watercolor paper must have good wet strength for this test.) The amount of color that remains on the paper determines the staining factor; sap green, for example, leaves a dark stain and rates a 10, while manganese, a nonstaining pigment, rates a 0. (Ways to use these staining and nonstaining characteristics are explained in a later chapter.)

Texture, determined by the ingredients used in a paint's manufacture, is revealed when you apply the pigment on a wetted area (here, below the black line) and allow it to spread and settle on its own. You'll best be able to see the texture of a pigment when you put it down as a juicy wash without manipulating it, letting the color settle at will on the paper's surface. Texture or lack of it can be used to create mood and atmosphere. For example, if I want to achieve a textural quality in a cloud study, I choose granular pigments like burnt sienna, ultramarine blue, cerulean blue, and raw sienna. If I desire serenity in the cloud study, smooth pigments like Antwerp blue or Winsor blue with brown madder and raw sienna will create this effect. Using one granular pigment moderately will not overstate its texture.

Cost varies according to quality and specific pigment. First, I look for artist-quality paints. I don't recommend the student-grade pigments because they are less pure and, to reduce the selling price, are made with fillers that can cause a painting to look chalky. I compare buying watercolors with buying house paint. With the inexpensive kind, you'll need two coats to cover, while a good-quality paint does it in one. So in the long run, better paints are more economical. Artist-quality pigments range in price because some, such as the cadmiums, are made from expensive and precious materials. I have tested and adopted some alternatives that are more economical and more transparent. (See the examples on pages 27–28.)

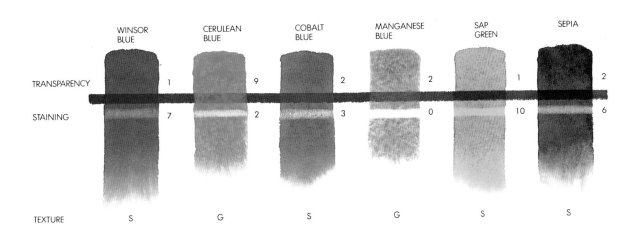

	WINSOR BLUE	CERULEAN BLUE	COBALT BLUE	MANGANESE BLUE	SAP GREEN	SEPIA
TRANSPARENCY	1	9	2	2	1	2
STAINING	7	2	3	0	10	6
TEXTURE	S	G	S	G	S	S

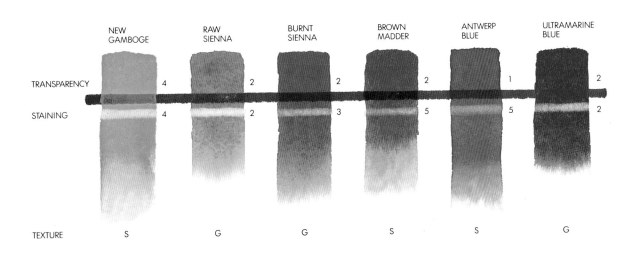

	NEW GAMBOGE	RAW SIENNA	BURNT SIENNA	BROWN MADDER	ANTWERP BLUE	ULTRAMARINE BLUE
TRANSPARENCY	4	2	2	2	1	2
STAINING	4	2	3	5	5	2
TEXTURE	S	G	G	S	S	G

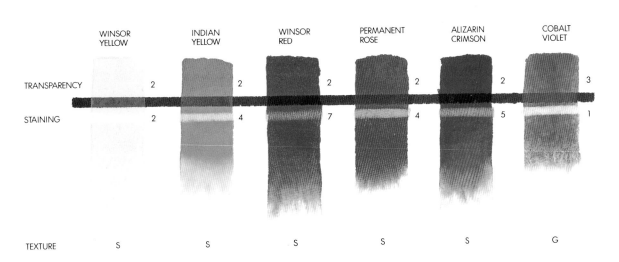

	WINSOR YELLOW	INDIAN YELLOW	WINSOR RED	PERMANENT ROSE	ALIZARIN CRIMSON	COBALT VIOLET
TRANSPARENCY	2	2	2	2	2	3
STAINING	2	4	7	4	5	1
TEXTURE	S	S	S	S	S	G

PRIMARY PALETTE
Six Basic Colors

The six hues that make up my basic palette are new gamboge, raw sienna, burnt sienna, brown madder, Antwerp blue, and ultramarine blue. I find this color range very flexible for landscape paintings.

The chart shows the variety of hues you can achieve with just the six basics. Each block of color leads to a horizontal path where it meets another hue, resulting in gradual mixtures. For example, follow down from burnt sienna and Antwerp blue to the first horizontal path, where these colors mix, creating pine greens.

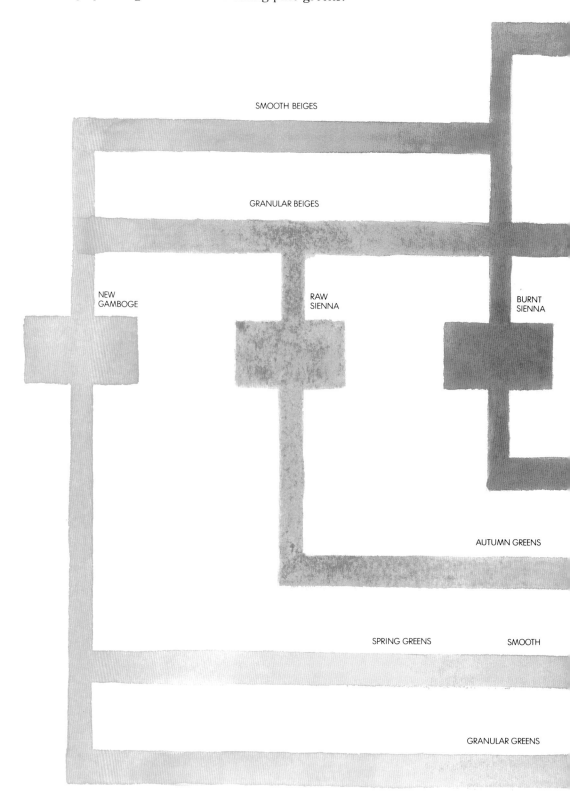

SMOOTH BEIGES

GRANULAR BEIGES

NEW GAMBOGE

RAW SIENNA

BURNT SIENNA

AUTUMN GREENS

SPRING GREENS

SMOOTH

GRANULAR GREENS

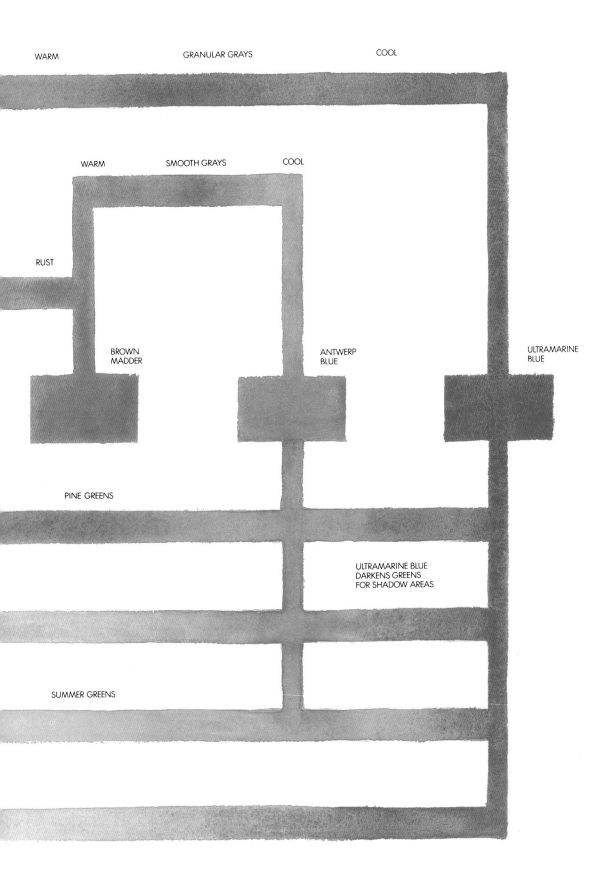

WARM GRANULAR GRAYS COOL

WARM SMOOTH GRAYS COOL

RUST

BROWN
MADDER

ANTWERP
BLUE

ULTRAMARINE
BLUE

PINE GREENS

ULTRAMARINE BLUE
DARKENS GREENS
FOR SHADOW AREAS

SUMMER GREENS

SECONDARY PALETTE
More Colors

The pigments in my secondary palette allow me to paint a broader range of subjects and make additional techniques possible. I've made some suggestions for ways to use them; through experimentation you will increase your color knowledge and develop the palette that works best for you.

WINSOR BLUE. This staining color can be used in a mixture with nonstaining darker values. When you lift out color to establish negative shapes, the Winsor blue remains. Mixed with brown madder, it yields dark, rich values of warm or cool grays; mixed with burnt sienna, it contributes to beautiful pine greens. Winsor blue is useful for rendering water and the high-altitude skies of mountain landscapes. Mix this pigment with Winsor yellow to get the viridian color of water in the Caribbean.

CERULEAN BLUE. Used discreetly, this very opaque pigment can prevent washes from becoming chalky. Its granular quality lends itself well for washes when you're depicting snow, skies, water, flowers, and backgrounds in still-life subjects. Mix a little cerulean blue with warm or cool grays, as shown in the primary palette chart, to achieve the silvery patina of old wood barns or fences. Cerulean is also useful for shadow areas of flesh tones.

COBALT BLUE. You cannot achieve real darks with this color. If you pile it on, it creates a flat tone; for this reason many people rate it high in the opaque category. Use cobalt blue as a neutralizer for other colors and as a gentle wash over areas where you want to create a bluish tone for atmospheric perspective. It's also good for shadows on flesh tones. Neither smooth nor granular, this color will take on the textural qualities of the pigments it is mixed with.

MANGANESE BLUE. The most interesting feature of this pigment is its nonstaining quality. You will notice when you mix this color with others that in a very few moments it settles to the bottom of the mixing tray, while the other colors remain suspended in the water. The advantage of this is that the manganese settles into the paper first, causing the other colors to dry on top of it; then, because the manganese doesn't stain, you can remove all the colors almost to the white of the paper. For best results, the other colors you mix with the manganese should be rated 5 or lower on the staining scale (see chart, page 23). This allows you to paint in dark and medium values and lift out lights for the negative shapes.

SAP GREEN. The strong staining quality of this pigment limits its use in areas where you might need to lift out color for white highlights. In such places you should use greens mixed from nonstaining yellows and blues instead. I use sap green almost exclusively where I want to achieve very dark sections, mixing it with a dark value of a color with low staining quality. Lifting off darks from such a wash results in green negative shapes that work very well as leaves or branches in floral subjects or as shimmering reflections of foliage on water.

SEPIA. A very transparent color rated high for staining quality, sepia is good for establishing darks in close-up subjects like old, weathered wood that require a textured underlay. In this technique, the sepia is applied first and a nonstaining medium value is placed over it. When the surface is dry, highlights and light patterns are lifted out with a bristle brush.

WINSOR YELLOW AND INDIAN YELLOW. Both very transparent, Winsor is a cold yellow, while Indian is warm. On the color scale these hues are close matches for the cadmium yellows, which have a high degree of opacity and are more expensive.

WINSOR RED. Because of this color's transparency I choose it over the cadmium reds, which have the same traits as the cadmium yellows. This is a rather cool red, but with a touch of Indian yellow it can be warmed up nicely, all the way to a beautiful orange. Mixing Winsor red, Indian yellow, and burnt sienna results in good flesh tones. Neutralize these flesh tones with cobalt blue for shadow areas.

ALIZARIN CRIMSON. A beautifully transparent color, alizarin crimson is most often used for flowers, morning and evening skies, or any subject that calls for rich, cool reds. Crimson lake is purer and colder in color, and may be considered an alternative.

PERMANENT ROSE. If flower paintings are your forte, permanent rose is a pure, beautiful hue that enables you to achieve the vibrancy and freshness of red blooms. Mixed with a little cobalt violet, for instance, it enhances both apple and cherry blossoms.

COBALT VIOLET. This luxury pigment is one of the most expensive in my palette. It has lovely low-staining qualities and is very granular. Excellent for flowers, it is also good for creating warm, hazy blue atmospheric perspective in distant objects when mixed with cerulean or cobalt blue. Overglazing large areas is tricky, as this pigment lifts very easily.

VIRIDIAN. I use this pigment occasionally because it is very effective for shadows and neutralizing skin tones in life and portrait paintings. Mixed with Winsor yellow, it makes lovely spring greens; with raw sienna, beautiful autumn greens. Viridian is a must for painting in the Caribbean. Its graininess helps create mood and atmosphere in paintings.

MIX & MATCH

I endeavor to use a limited number of pigments when doing a painting, and so limit the number of colors in my palette. Winsor & Newton manufactures eighty-three colors. Where do you draw the line? Over the years my palette has grown from the original six primary hues to eighteen colors at present. Your own preferences will evolve as you reach higher and higher skill plateaus. On occasion, for convenience or because of certain characteristics, I will tuck in another color somewhere on the mixing tray, but for the most part I have learned to mix many hues from the existing ones in my palette.

WINSOR YELLOW · MANGANESE BLUE · ANTWERP BLUE

MIXED · TUBE

VIRIDIAN GREEN

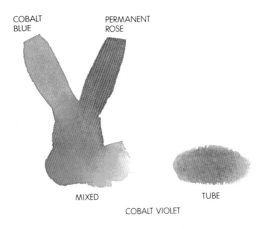

COBALT BLUE · PERMANENT ROSE

MIXED · TUBE

COBALT VIOLET

Viridian green is a pigment I would find room for in my palette when painting in the Caribbean Islands. Since I don't require this color often in the northern hemisphere, I prefer instead to mix it whenever the need arises, using Winsor yellow, manganese blue, and Antwerp blue. In transparency, staining, and textural qualities the mixed color closely matches the pigment sold in the tube.

Cobalt violet may be too expensive for the "poor, starving artist," but you can match the color of this pigment fairly closely by mixing the less costly cobalt blue and permanent rose. Unfortunately, that way you lose out on the advantage of the low-staining and granular qualities of the manufactured tube color. Substituting manganese blue captures more of the granulation and low staining, but the color is not as fresh.

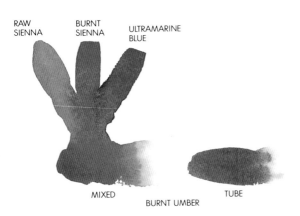

RAW SIENNA · BURNT SIENNA · ULTRAMARINE BLUE

MIXED · TUBE

BURNT UMBER

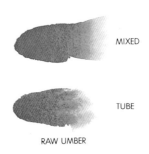

MIXED

TUBE

RAW UMBER

Burnt umber is a color that has not been in my palette for years, as I can mix it with ease from raw sienna, burnt sienna, and ultramarine blue. However, I do not get the granular quality of the manufactured tube color.

Raw umber can be mixed from the same three colors but using a larger proportion of raw sienna to arrive at the tube color.

MEET THOSE OTHER GUYS

Some pigments have qualities and characteristics that I find undesirable. Yellow ochre and the cadmiums, for example, are quite opaque, and the cadmiums are fairly expensive. For these reasons I instead use the much more transparent alternatives shown here, substituting raw sienna for yellow ochre; Winsor red for cadmium red; an orange mixed from Winsor red and Indian yellow for cadmium orange; Indian yellow for cadmium yellow; and Winsor yellow for lemon yellow. As you can see, the differences in hue are so slight that they would be barely detectable in a painting.

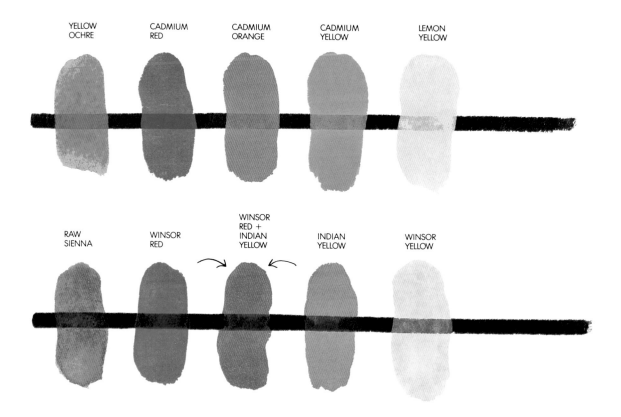

YELLOW OCHRE CADMIUM RED CADMIUM ORANGE CADMIUM YELLOW LEMON YELLOW

RAW SIENNA WINSOR RED WINSOR RED + INDIAN YELLOW INDIAN YELLOW WINSOR YELLOW

A MIXING PALETTE

A proper mixing palette is worth the investment. Your colors will have a permanent location, and you will know exactly where they are from painting to painting. If the keys on a piano were changed every time a person was to play it, the results would be chaotic. It is no different for an artist.

The palette I've designed fits into my Easel-Mate and enables me to divide my pigments into three groups of six. The colors in the center row form my primary palette; the remaining twelve are secondary hues. The mixing wells consist of five sections of varying sizes. I find this very economical because I can keep color mixes throughout a whole painting and don't have to worry about their running together and possibly going to waste. Clean your palette after each painting and keep the wells topped up with pigment squeezed from the tube as needed.

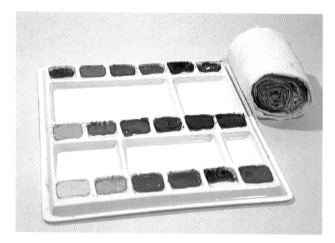

WATER, WATER

You need to control the amount of moisture in your brush when you pick up pigment. There are basically three methods, the first of which I can't recommend—licking the brush, since some pigments are poisonous. A "flicker"—I used to be one—flicks the brush to remove water from it, which works very well. A "wicker" uses an absorbent surface, which is much more sanitary. For this approach, fold paper toweling to form a roll 3″ in diameter, or wrap a few pieces of paper towel around a sponge. Periodically the sponge can be washed out and new towel wrapped around it to ensure a reasonably clean surface. If the paper towel does not have wet strength—that is, if little bits come off when it's wet—tucking the roll into a nylon stocking will solve the problem.

A 2-lb.-size plastic margarine tub makes a good water container. Because it's important that the water stay clean, I rinse my brush by dipping it into the water and then dabbing it on my absorbent roll. Doing this several times will remove all color from the brush and keep the water clear.

MONEY-SAVING TIPS
Waste Not . . .

My former teacher Fred Fraser preached frugality; with him in mind, it seems as good a time as any to make some suggestions on the economics of painting. I've figured out some ways to put Fred's philosophy into practice that you may find beneficial and suitable to your own working habits. (If not, don't tell Fred!) Here are a few ideas for being thrifty with your paints.

It's been said that you get a quicker response when mixing colors if you use pigments squeezed directly from the tubes. Artist-quality tube pigments that have been allowed to dry firm on the palette, however, take only a moment or two after wetting to respond satisfactorily. If you use gooey, freshly squeezed pigments, you will pollute them as you go from one to the other picking up color for a mix. Imagine going to yellow with blue on your brush; before long your yellow will become green, and eventually you'll have to discard it and replace it with fresh pigment. You could, of course, wash your brush clean after picking up each color, but this results in wasting paint too. With gooey pigments it's difficult to judge how much your brush picks up, and often the excess ends up in the water jug or on a tissue. Tut-tut, waste, waste, waste! With firm pigments none of this will happen, especially the polluting. Sure, maybe the top skin of the firm color will be polluted, but not much is lost when you clean it off.

Pigments like raw sienna, alizarin crimson, Winsor blue, viridian green, and a few others tend to shrink and crystallize in the tray after repeated use. Often they will fall out in small bits and cannot be retrieved. To avoid this problem I fill my tray with just enough pigment to last a few paintings.

When you've just finished a painting session or have just replenished a tray with pigment, the paints are soft and runny; if the tray gets tipped during transport, you're faced with the problem of colors running together. A palette with a cover that seals each pan of pigment will prevent this from happening. Rather than spend money for lids, though, you can use masking tape to seal the pans. My mixing palette was designed to allow for this, and has saved me money many times. When you reach your destination, remove the tape to allow the pigment to dry.

If your paint tubes refuse to open, carefully heat the top part of tube and cap with a match. Use a tissue to protect your fingers when handling the hot cap. Twisting it off is usually easy. Invest in a pair of small pliers to squeeze every bit of pigment from paint tubes. I collect throwaways after workshops. Haven't bought pigment in years! Are you paying attention, Fred?

PAPER
RAGS TO RICHES

Paper is the most important material in watercolor painting. The paper that sets the standard for me is Arches handmade 100 percent rag. Rag paper withstands the rigors of time, maintains good wet strength, and has a wonderful affinity for the pigments. Beware of those inexpensive pads of paper that say they are for watercolor as well as for pencil, charcoal, pastel, acrylics, and so on. Save your money—they won't work like Arches.

Besides money, you will save time and frustration by using a good-quality paper. Beginners often believe they can learn to control watercolor on cheap paper, but pigments do not respond well on poor-quality surfaces. Also, you will be limited in the techniques you can use. Even if you persevere in the struggle, the results you achieve may be mediocre at best. And then when you do start using good paper, you'll find that the pigments behave differently, meaning you will spend a lot of time and effort to relearn.

Here's a simple test to determine paper quality. Apply a small strip of masking tape to the surface with moderate finger pressure; then remove the tape. If it lifts fibers or tears the paper's surface, keep the piece of tape and throw away the paper. If the surface fibers don't lift, it's a good indication the paper is tough and has good wet strength, which means it will probably withstand techniques like scrubbing with a damp brush to lift color, squeezing—applying a blunt tool to create details and highlights—and using masking fluids.

WEIGHT

Arches paper is available in the following weights: 90 lb., 140 lb., 300 lb., and 400 lb. These amounts are determined by what 500 sheets (a ream) of the 22″ × 30″ size weigh. The heavier the paper, the thicker it is and the higher its cost. Lightweight paper buckles when wet and dries faster than heavier types. All weights have about the same affinity for pigments.

Two weights should meet the needs of most artists. For leisure-time and beginning painters I suggest 140-lb. paper because it is economical. Buckling and drying are easily coped with, as explained below. Advanced and professional artists, who can better justify the expense, usually use 300-lb. paper, especially for larger paintings (15″ × 22″ and up), because it retains moisture longer and stands up better.

SURFACE

Arches paper is available in three textures: hot-pressed (smooth), cold-pressed (medium), and rough. Paper surfaces have a "tooth"—texture created by the minute fibers that are not ironed down in manufacturing—which helps hold a wash of pigment in place. Rough paper has the most tooth, offering considerably more control than smooth paper, which has next to none.

If you are a leisure-time or beginning artist, I recommend that you use rough paper until you learn and understand the control of washes. As you gain expertise and confidence, you may choose to use cold-pressed paper, which has sufficient tooth to offer good control and gives a lovely granular quality to washes. Hot-pressed paper requires greater technical skill than the other two surfaces. As you advance in ability, you certainly should experiment with it to gain an understanding of the results it offers. Who knows, maybe you will find smooth paper more suitable to your personality and appropriate for what you want to say with your paintings.

COPING WITH 140-LB. WEIGHT

My recommendation that you use 140-lb. paper is not just for reasons of economy, but to help you learn and understand how to control pigments on a surface that is more demanding and faster drying than the 300-lb. weight. You have to plan your painting carefully and think about washes in advance, then work quickly. This results in paintings with a fresh, spontaneous quality.

BUCKLING. One well-known way to get around the buckling problem is to soak your paper in water, which allows it to expand, and then tape, staple, or tack it to a mounting board. As the paper dries, it shrinks and stretches tight; when rewet during painting, it will not buckle. The disadvantage of tacking or stapling paper to a board, however, is that juicy washes can creep over the edges and wick under, spoiling the back. Many artists find stretching paper a bothersome, time-consuming task. If you're one of them, the following alternative solution may be of interest to you.

Using masking tape, attach the edges of a sheet of dry paper to a mounting board, preferably one made of Masonite, Plexiglas, or Coroplast (a strong, lightweight white plastic material with a corrugated center, usually available at lumber or building supply stores). Confine washes to specific areas such as background, middle ground, or foreground, and dry each layer completely (a hair dryer speeds

things up) before going on to the next. That way the paper will shrink gradually, eliminating most of the buckling. If your first wash must cover the paper completely, an effective method is to wet the paper first, quickly sponge off excess water, and immediately apply your wash. That way the paper does not have a chance to absorb a lot of moisture and expand. As long as you remember to dry the paper thoroughly between washes to shrink it back each time, you will cope quite nicely.

KEEPING PAPER WET. Doing a painting completely in the wet-in-wet technique, establishing all values at once, is a fun approach. But 140-lb. paper dries too quickly for it to work well. To get around this problem, soak your watercolor paper in water, then lay it on three or four layers of wet paper towel and gently press out excess moisture and air. That way your paper will remain damp for a long time, facilitating the wet-in-wet technique.

Arches watercolor paper comes in three textures. Left to right: rough; cold-pressed (medium); and hot-pressed (smooth).

USING PHOTOGRAPHY

Learning to use photographs you have taken can aid your painting. Photos enable you to work in a studio, where the ultimate atmospheric conditions exist and where you will initially learn to master the many techniques of watercolor. You must, however, get outdoors to understand the demands of painting on location. It is said that Nature is the best teacher, and the outdoors is an exciting and important arena in which to study.

Shooting your own photographs will get you out there to experience a wealth of subjects, and photographing scenes from several angles gives you reference material for studio use. Doing quick, on-site pencil sketches as well, time and weather permitting, is also important. Initially you may tend to copy photographs, but this must be avoided. As you gain confidence in your abilities and achieve higher and higher skill plateaus, you will use photos solely for reference, as reminders of the anatomy of subjects, allowing your personal interpretation to influence the end results. You may have read about how some artists project a photographic image and trace it to do a painting. This may be all right in commercial art, where time and cost are important concerns, but in the fine art field it is an absolute no-no.

Color slides and various types of prints are all useful photographic reference material. A slide gives the truest color, which can be important if you are rendering a subject that depends on it. I view color slides with a Kodak Carousel 5400 projector and a 3⅝″ × 3⅝″ viewing screen that is sufficiently bright to use beside a north window, my light source—the best one—for painting. Black-and-white prints work well if color is not important but subject detail is; color prints, while less precise than slides, are useful if you need to refer to the color of a subject.

I prefer to take Polaroid photos when I'm painting on location. When I've decided on a subject, I take an instant snapshot so that if I can't finish or am

forced to quit because of inclement weather, I have an immediate reference. Sometimes an interesting lighting condition occurs while you're doing a painting, and a Polaroid is a good tool to capture that moment. When using one, you will get better results if you adjust the light control to a lighter setting. Check your manual and experiment until you establish the best setting for your subject.

When choosing a camera, look for one that allows flexibility in shooting both reference photos and your own paintings. I use a 35mm single-lens reflex camera with an automatic or manual mode that can be adjusted for varied exposures, depending on the subject lighting. Most cameras come with a 50mm lens, which has limitations, so after selecting a camera body you might want to consider purchasing a zoom lens, which enables you to take wide-angle and telephoto pictures. I find a 35mm to 80mm very suitable, but better still is a 35mm to 105mm. The lens should have macro capability so you can take close-up shots of small subjects, a feature that will allow you to photograph your work. If your pocketbook won't allow for this type of equipment, an inexpensive, fixed-focus camera offers adequate success for reference shots.

PHOTOGRAPHING YOUR WORK

I have photographed paintings in natural light with satisfying results. Because print film does not capture the true color of a painting, I do all my shooting with Kodachrome 64 slide film, which is intended for use in daylight. Positioning myself in a shaded area, I hold the camera directly in front of the painting and fill the frame with the image, then snap the shutter. I take two shots, especially if the painting has a lot of light areas and darks in high contrast. I shoot the first as the light meter dictates; then, switching to the camera's manual mode, I open the shutter an extra stop—from $f/8$ to $f/5.6$, for example—to allow more light to reach the film so details in the dark areas will register. The lights will be slightly lighter than in the original, but not so much as to spoil the results.

In summer the temperature (color) of light in shaded areas is best between 9:00 A.M. and 5:00 P.M., and during winter, between 11:00 A.M. and 2:00 P.M. The lower the sun in the sky, the warmer the color temperature, which affects the results you get in photographs. I'm sure you have taken pictures early in the morning or evening and noticed how yellow they appear.

I have never had much experience using a flash to photograph paintings. I shot all the material for this book using artificial lighting. For more information on how to photograph your work in different lighting situations, I suggest you consult a book on the subject.

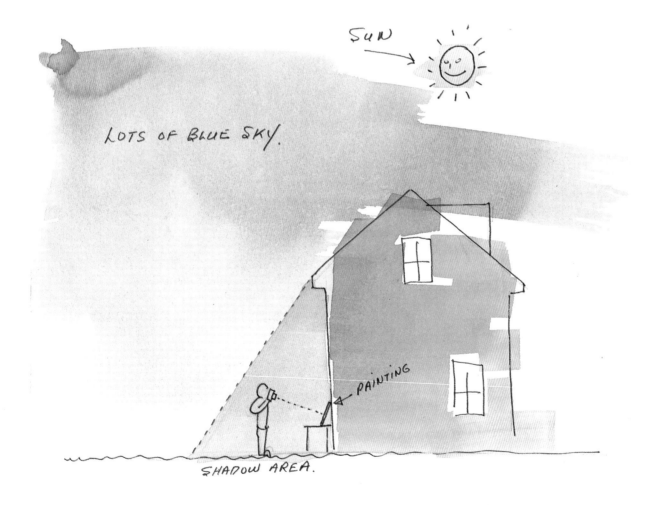

BASIC COMPOSITION
My Guides

To handle the medium of transparent watercolor intuitively, you have to know and understand some of the basic rules of design. Keeping logic and simplicity foremost, this chapter touches on these important elements, guiding you toward achieving good composition in your paintings.

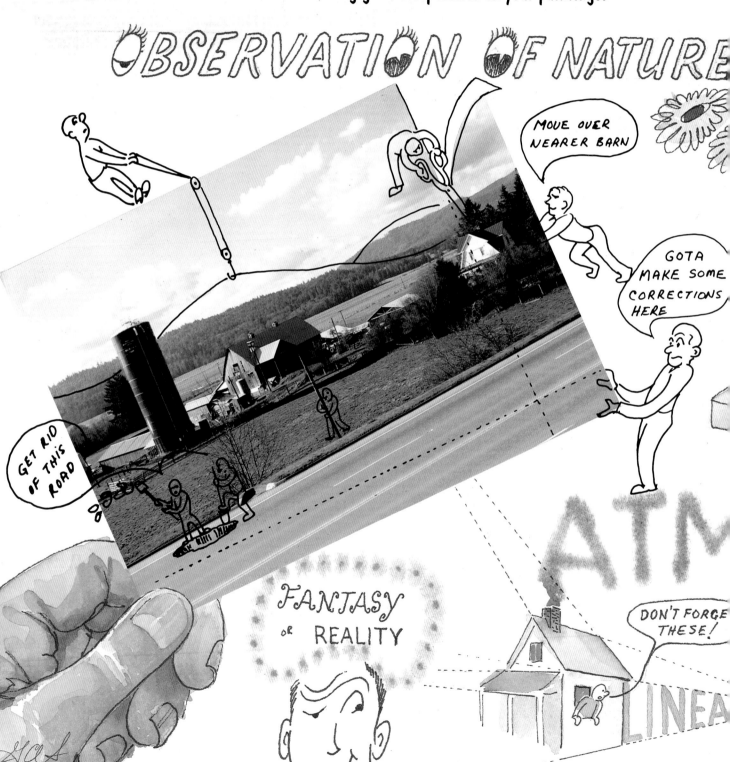

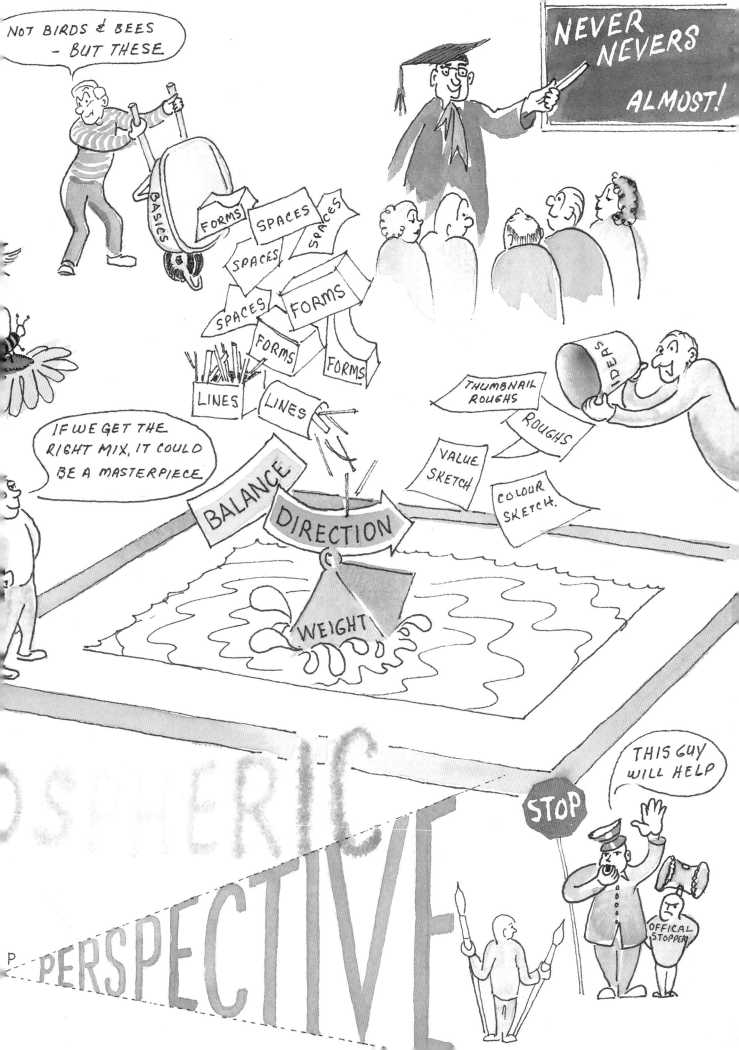

OBSERVING NATURE

I wish I had a nickel for every time I've heard "I put it (the post, the tree, the building) there because that's where it was." It seems most beginning artists are more concerned with rendering a subject as it appears rather than with composing a painting that expresses his or her unique style and is all that a painting could be. The "could be" includes good composition, color, value, and path of vision—all elements of good design. Don't hesitate to "play God." Move trees, mountains, or whatever to create satisfying composition and interest in your painting.

When recording specific historic locations and properties like those shown here, I aim to capture the physical qualities fairly accurately, yet still see the need to make subtle changes to ensure originality, as a comparison of the photos with the paintings will show. If you were to visit these towns, you could readily find these scenes.

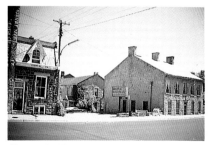

Street in Fergus, Ontario; painted on location.

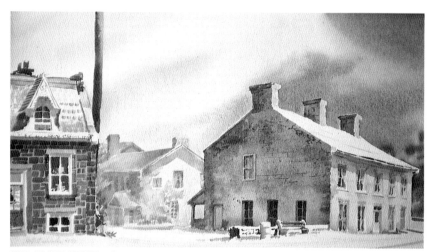

THE GROVE GROUP, 12″ × 22″ (30.5 cm × 55.9 cm), Arches 300-lb. cold-pressed paper

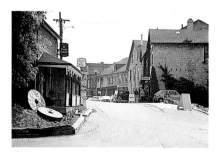

Street scene in Elora, Ontario; painted on location.

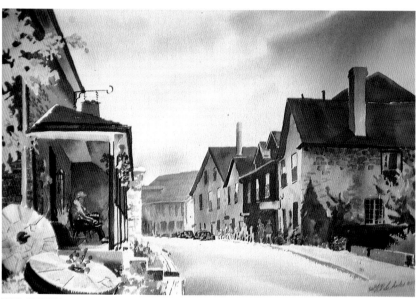

MILL STONES, 11″ × 15″ (27.9 cm × 38.1 cm), Arches 300-lb. cold-pressed paper

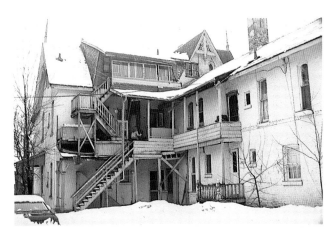

McConkey mansion, Barrie, Ontario.

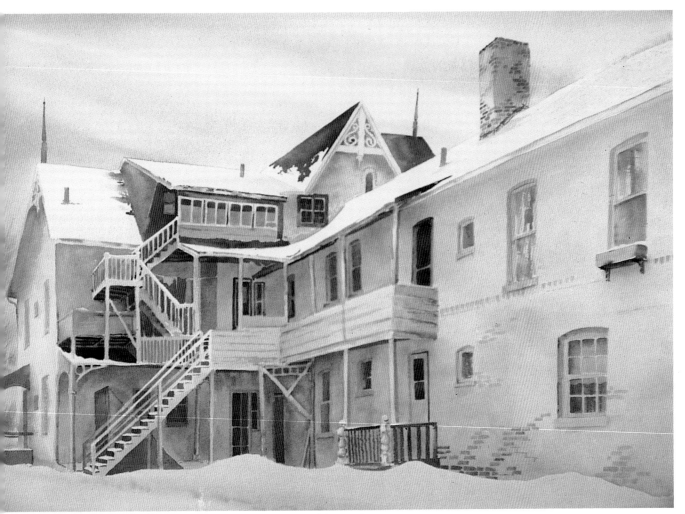

UPPITY-UP, 22" × 30" (55.9 cm × 76.2 cm), Arches 300-lb. cold-pressed paper

COMPOSITION
THE RIGHT MIX OF BALANCE, DIRECTION, AND WEIGHT

Composition is of prime importance. Paintings that are weak in either drawing or painting technique can be acceptable when good compositional qualities are present. Badly composed paintings, however, just won't survive. It all boils down to good design.

When composing a painting you must consider how to arrange all elements harmoniously within the pictorial space. Things to keep in mind include:

balancing the placement and proportion of all forms in space

directing the viewer's path of vision with line

weighing all components through size, color, and value

BALANCE

In a balanced composition, line and form are compatible and their arrangement in space is harmonious. In an unbalanced composition, line, form, and space look awkward, create tension, and lack harmony. To develop your sense of balance and spatial harmony, take a random-shaped piece of colored paper and experiment with positioning it different ways on a rectangular background, a format many of your paintings will take.

BALANCING ONE OBJECT. When deciding on where to locate each element in a composition—a barn, a house, a tree, a boat, for example—keep in mind that improper placement can result in poor balance. Let's look at what happens when you move a circle around in a rectangle.

BALANCING TWO OBJECTS. Two objects in a rectangle present another challenge. Spatial harmony can be achieved by giving one object prominence, establishing a pecking order.

LINES IN A RECTANGLE. Lines naturally also play an important role in composition because they divide up the pictorial space.

Placed in the center, the circle appears static, having equal space top to bottom and side to side. This creates tension, as the equal spaces fight for attention; the eye cannot decide if the circle is pressing in any particular direction or if it is exactly centered.

Here the circle presses toward the edge of the rectangle and gives the feeling of moving out of it, causing poor balance.

In this example the circle appears to be trapped in the corner and gives a feeling of restriction. Again, poor balance.

Now look at the position of the circle in these four examples. When you place the circle off-center and away from the corners of the rectangle, the space around it gives a sense of balance and spatial harmony that satisfies the eye.

 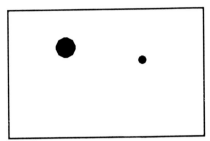 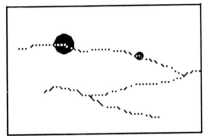

Two circles of equal size compete for attention; each seems to say, "Look at me! Look at me! Look at me!" This causes tension.

Spatial harmony exists here because a pecking order has been established, creating a sense of balance. First you see the larger circle, then the smaller.

Adding a line provides direction—a path of vision that allows one object to relate to the next in space. A third object adds to the overall harmony.

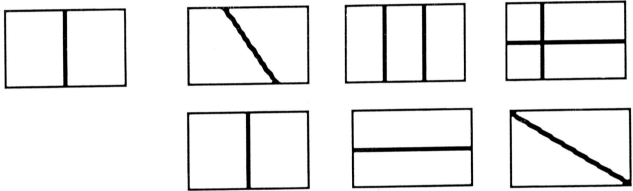

Handling lines incorrectly can result in poor composition. When a line is placed in the center, it divides the rectangle into equal spaces, creating a static look. The eye cannot decide if the line is exactly centered and if

one space is larger than the other. Both spaces are of equal importance and vie for attention, just as in the example of the two circles. Note how tension results from competition among the various elements.

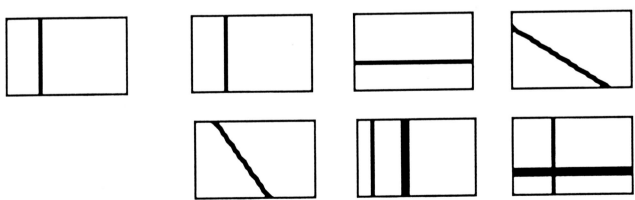

Now look at what happens when you arrange lines correctly in a rectangle. Placing a line off-center divides the rectangle into unequal spaces that give a sense of balance and visually satisfying spatial harmony. Each

shape is different and none is in competition with another. Adding thickness—weight—to a line makes it more dominant and establishes a pecking order that is pleasing to the eye.

DIRECTION

Once you've established compatible compositional elements, you must think about the direction in which you want the eye to travel—a path of vision. The subtle arrangement of lines, spaces, and forms will help create this. Keeping the eye within the picture is important and takes careful planning. The path of vision should create a subtle flow through the painting while tying it together. Subtle is the key word here; the direction should never look contrived or obvious.

The corkscrew is one possible motif to use; it takes your eye into the painting and leads it from one area to the next in a circular motion.

The zigzag leads your eye into and through the painting in a Z-shaped linear motion, offering several paths of vision that hold the viewer's attention.

WEIGHT

When you're composing a painting, weight is the most important of the three main design principles to consider. It is determined by the size, value, and color of the lines, spaces, and forms that make up a composition. Use these variables to create a pecking order among the different compositional elements.

The weight of an object is established not only by its size but also by its value. Light values—soft or pale colors—tend to recede and are used to render objects in the distance; dark values—strong or rich colors—tend to advance and make objects appear closer to the front of the picture plane. Color, too, affects the weight of objects; cool colors like blue recede, and warm colors and whites advance.

Although the background trees are warm in color, their lack of detail and the cool blues introduced there keep them back where they belong. The foreground objects, painted in cool colors, are brought forward with dark details and liberal amounts of white.

Note how the warm color of the silo brings it forward. The value is right, the color is wrong. It should be bluer or grayer.

NEVER-NEVERS

Illustrated here are some of the compositional faults that occur most often in my workshops. I define these as "never-nevers," since I don't believe there is a way of making them work.

Well, almost never. Having given you some guidelines, I now suggest you break them and make your compositions work in other ways. For instance, put your main subject in the center but make it look off-center by using color or another object to weigh it toward one side; if your central subject is a boat, a figure placed at one end will prevent it from looking centered. Make shapes that are the same size look different by adjusting their weight through color and value. These are the artist's challenges.

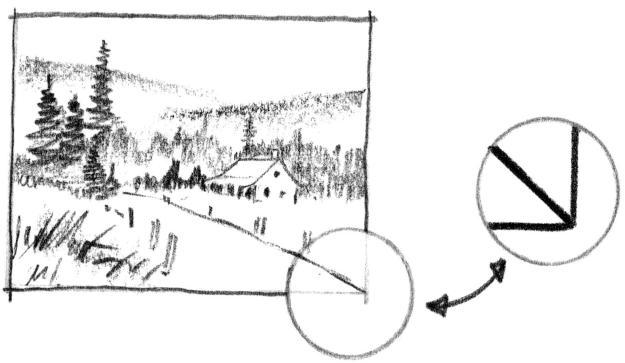

The "arrow" formed by the diagonal line and the corner of the paper creates a path of vision that leads your eye out of the painting.

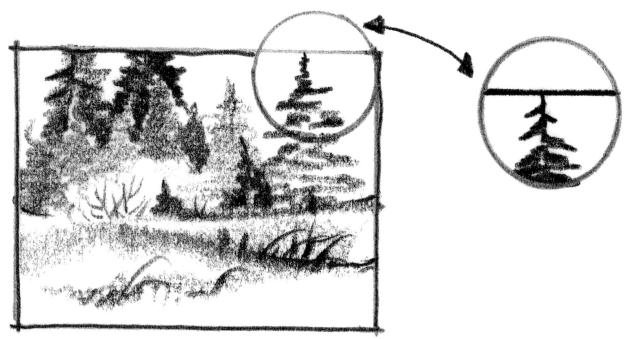

The tree appears to hold up the edge of the mat, causing a feeling of indecision and tension.

Building touches left edge of composition: indecision.
Buildings lined up side by side: no third dimension.
Silo edge meets peak of roof: tension.
Hill held up by roof and silo: static.
Fence perfectly even: boring.

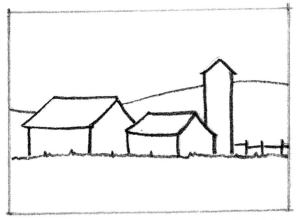

In this corrected sketch there is a sense of spatial harmony.

X marks the spot. You can't keep your eyes off it, and so enjoy the painting.

KNOWING WHEN TO STOP

It's been stated that it takes two people to do a painting—one to paint it, the other to tell you when to stop.

Many students have a tendency to overwork a painting and eventually spoil it. This is quite often a problem when you are just feeling your way into the medium of watercolor. As you develop your skills and style, stopping at the right time will become a gut feeling. When I start to put down the medium darks and final darks, I constantly squint or step back to evaluate the overall painting. If I am not certain about how far to go in a particular area, I work on another section; bringing a less troublesome portion along often helps me make a judgment in the other area.

Our personality comes out in paintings and is partly revealed in the amount of detail defined. It is important, however, to resist the temptation to overdo it. I keep two thoughts in mind that help me put the brush down and stop working: 1) A painting should make a statement—one that doesn't need words. I don't want to resort to a verbal explanation. As Zoltan Szabo put it, if you need to use words to explain a painting, you should be a writer, not an artist. 2) A painting should be understated. I don't want to dominate communication between the viewer and the painting. It's a little like a conversation between people. If one person always dominates and does not allow an exchange of ideas, he or she is soon avoided. I don't want people to avoid my paintings; by making an understatement, I invite them instead to contribute.

This can be best summed up in a visual test I've conducted with some of my students. I briefly show them a painting of a brick building in which I've defined only a few of the bricks, using their shapes to create an interesting pattern or a path of vision within a given area. Then I put the painting away and ask the students how many bricks were rendered on the building. The answer has varied from all to most, when in fact I have shown only a few. A viewer sees the bricks, realizes that he is looking at a brick building, and adds more bricks in his mind's eye. I use this theory for rendering leaves, branches, or anything that is a component of a larger whole.

PERSPECTIVE

Knowledge of perspective allows you to depict objects intuitively in correct spatial relation to one another so that you can paint more complex and interesting subjects. You'll also be better able to see distortions and fix them in your compositions.

ATMOSPHERIC PERSPECTIVE

Atmospheric perspective gives a sense of depth and third dimension to a painting. It is achieved through color and value. Leonardo da Vinci explained it this way: The more distant an object is, the bluer, paler, and less defined it will appear. In painting I caution you on "paler," as you can have a hill, mountain, or building in shadow that will be darker than a closer object. In this case, less definition and more blue become necessary.

Let's examine what causes this phenomenon. The atmosphere—air—appears blue, as attested by the sky. It is the air between you and an object in the distance that turns the object bluer and paler. Natural and man-made pollution close to the earth—dust, chemicals, smoke, and so on—causes a distant object to be less clearly defined. Obviously the farther away an object is from you, the smaller it will appear and the less visible the details. For example, you can't see individual leaves on a tree or bush off in the distance; everything breaks down into big and small shapes, and it is these that you define in a painting. The degree of detail is a personal choice, of course, but remember: Less is best, more is poor.

The best way of seeing less detail is to squint. An out-of-focus photograph closely illustrates this.

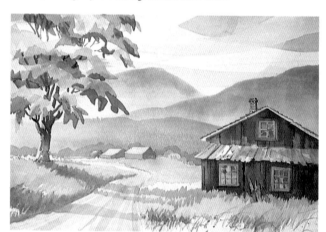

Landscapes lend themselves to creating atmospheric perspective using the three basics: bluer, paler, less defined.

A sense of depth is important when rendering close-ups. It can be achieved by showing a difference in value between objects that are even a short distance apart.

VP

LINEAR PERSPECTIVE

A vanishing point is where two parallel lines, like the iron rails of a railroad track, converge on the horizon. Most linear perspective we use involves two vanishing points. Three-point perspective occurs when an object is either above or below the horizon line, as is the house in the diagram; its third vanishing point is off the page. The roof is on a different plane and thus has its own vanishing point.

VP

EYE LEVEL OR HORIZON LINE

VP

B

A

F

E

D

C

THE SMALLER AN
OBJECT, THE FARTHER
AWAY IT APPEARS.

THE SHORTER A LINE, THE
FARTHER AWAY IT APPEARS.

HERE, LINE B IS SHORTER
THAN A, THEREFORE APPEARS
FARTHER AWAY.

LINES E AND F ARE
SHORTER THAN D, THEREFORE
APPEAR FARTHER AWAY.

SKETCHING

THE VISUAL THINKING

Pencil sketches are the best way to develop hand-to-eye coordination and improve your drawing skills. They are also a convenient way to think out a watercolor, especially when you're working on location. The tools are simple to use and easy to carry, and if you run into inclement weather or out of time, you'll have your quick sketches to fall back on for reference.

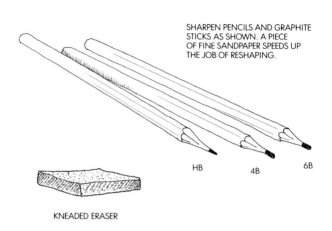

SHARPEN PENCILS AND GRAPHITE STICKS AS SHOWN. A PIECE OF FINE SANDPAPER SPEEDS UP THE JOB OF RESHAPING.

HB 4B 6B

KNEADED ERASER

SKETCHING TOOLS

When sketching on location I use a spiral-bound sketchbook so I can fold the cover back for a small, compact unit. Actually I have two along, one containing inexpensive paper for some visual thinking, the other containing 100 percent rag paper—which won't yellow or deteriorate—that I use for my "keepers."

Pictured here are just a few of the sketching implements I recommend that you try.

GRAPHITE STICKS WRAPPED WITH MASKING TAPE TO KEEP FINGERS CLEAN

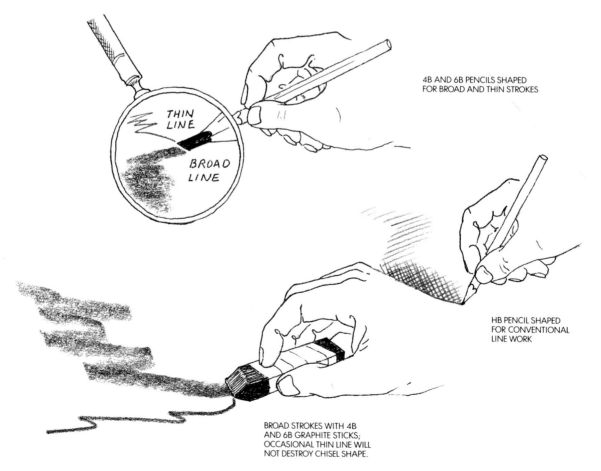

THIN LINE

BROAD LINE

4B AND 6B PENCILS SHAPED FOR BROAD AND THIN STROKES

HB PENCIL SHAPED FOR CONVENTIONAL LINE WORK

BROAD STROKES WITH 4B AND 6B GRAPHITE STICKS; OCCASIONAL THIN LINE WILL NOT DESTROY CHISEL SHAPE.

THUMBNAIL ROUGHS

Thumbnails are thoughts put to pencil. Their purpose is to organize your mind and help you develop the composition of your upcoming master-piece. Thumbnails are not intended to be perfect little drawings but gestures of the subject—quick, simple lines with which you can establish the position, sizes, and proportions of shapes in your composition. After looking through my thumbnails, I may render a value pencil drawing or a watercolor sketch based on the one that achieves my purpose.

These thumbnails are for the paintings on page 41.

VALUE SKETCHES

When painting in watercolor generally, the basic procedure is to develop the painting with washes, working from the lightest to the darkest value, always leaving the whites, lights, and mediums as you progress toward the darks. The same approach holds true when you're rendering a value sketch with pencil. When making such a sketch, I think in terms of the colors and techniques I will use in the eventual painting. The sketch then becomes not only a reference for the subject but also a watercolor plan. Of course, the better your knowledge of how watercolor works, the better able you will be to make sketches that are useful in your painting. My advice is, sketch, paint, sketch, paint, sketch, paint.

This pencil sketch was photographed in progressive steps to show the buildup of values from light to dark. In the margin are my thoughts about colors and techniques I plan to use for the painting. Light values are sketched in with a 4B giant graphite stick.

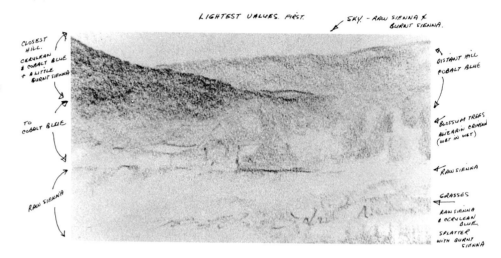

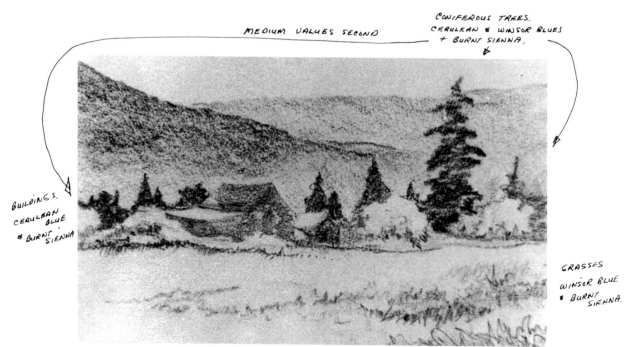

Medium values are defined with a 4B pencil and graphite stick.

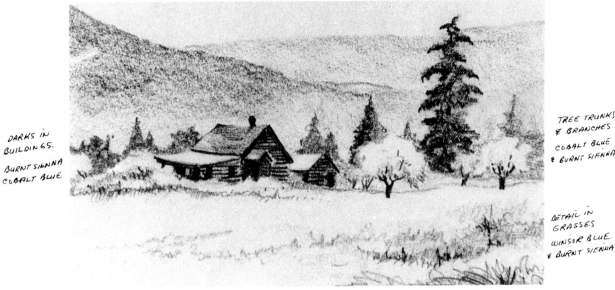

DARKEST VALUES THIRD.

CONIFEROUS TREES
DARK GREENS. WINSOR BLUE
 & BURNT SIENNA

DARKS IN
BUILDINGS.

BURNT SIENNA
COBALT BLUE

TREE TRUNKS
& BRANCHES
COBALT BLUE
& BURNT SIENNA

DETAIL IN
GRASSES
WINSOR BLUE
& BURNT SIENNA

Dark values come last; I complete the sketch using a 6B pencil for the details.

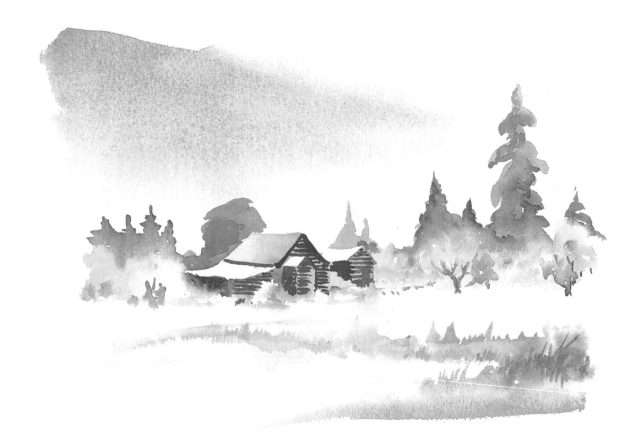

The color sketch is the result of my pencil-sketch planning. Note that I've softened the hill in the distance as an attempt to determine whether the haze of morning mist would create a suitable mood. A large tree behind the cabin helps establish a strong value contrast with the roof. In the foreground the path of vision leads the eye clearly into the painting. The blue at bottom right brings some of the background color forward.

DEBOSSING
Getting in the Groove

Smooth scribing instruments like the ones illustrated make it possible to create white negative areas in pencil sketches. Press the tool firmly on the paper to form a groove in the shape desired. Using a pencil or graphite stick, sketch over this impressed groove, and presto! Neat little negative lines and shapes appear.

DEBOSS BRANCHES, BLOSSOMS, AND GRASS WITH ANY OF THE TOOLS SHOWN HERE. USE A 4B GRAPHITE STICK AND PENCIL TO CREATE THE IMAGE.

PLACE CARDBOARD UNDER YOUR DRAWING TO PROTECT NEXT SHEET OF PAPER.

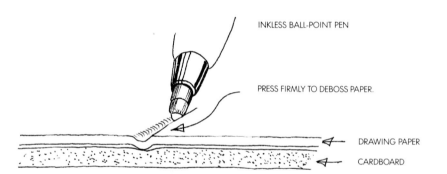

INKLESS BALL-POINT PEN

PRESS FIRMLY TO DEBOSS PAPER.

DRAWING PAPER

CARDBOARD

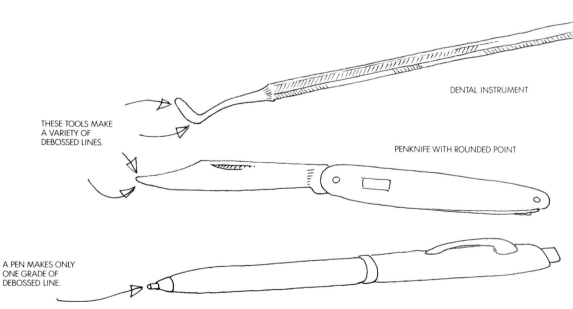

DENTAL INSTRUMENT

THESE TOOLS MAKE A VARIETY OF DEBOSSED LINES.

PENKNIFE WITH ROUNDED POINT

A PEN MAKES ONLY ONE GRADE OF DEBOSSED LINE.

INKLESS BALL-POINT PEN

WILLOW CREEK

White negative lines in these drawings—grasses and tree branches against dark backgrounds, the veining on the leaves— were created by debossing.

TECHNIQUES
The Ways and Means

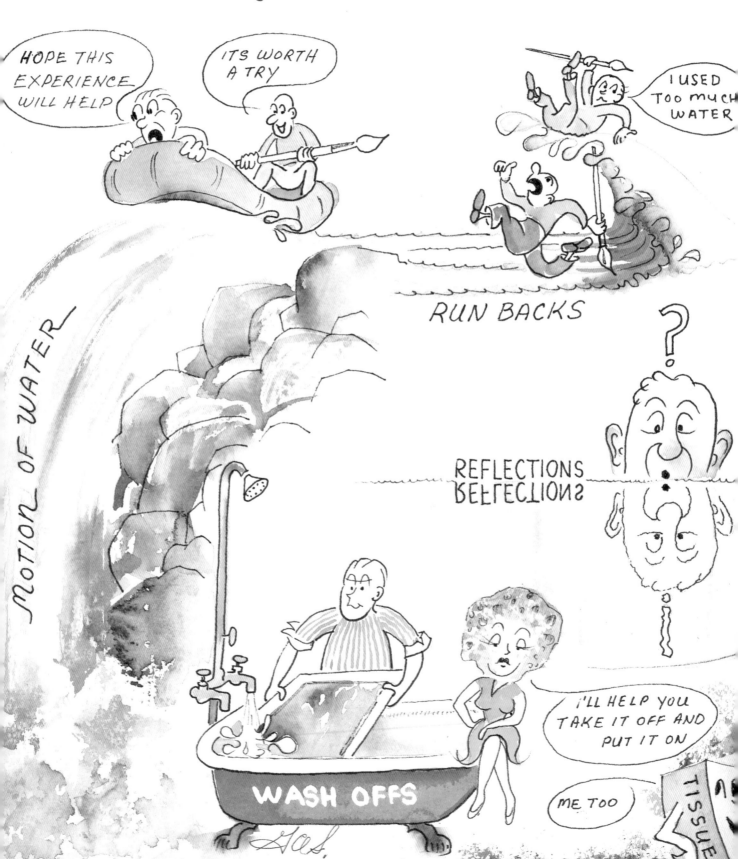

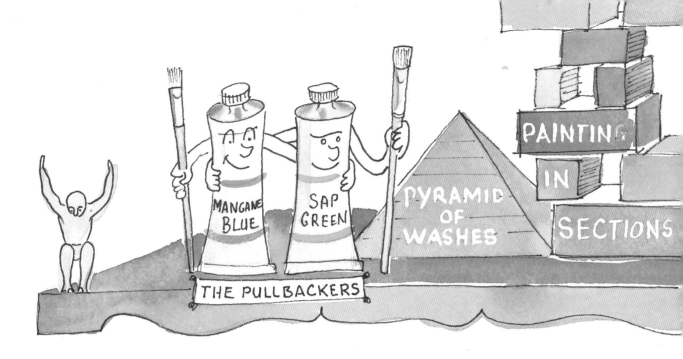

Learning to control watercolor and then applying this knowledge is what allows you to create successful images and aim toward—dare I say it?—masterpieces. Watercolor techniques are numerous and offer all sorts of possible ways to approach subject matter and arrive at a style. The following chapter carefully explains a wide variety of painting techniques that will help you reach those exciting skill plateaus.

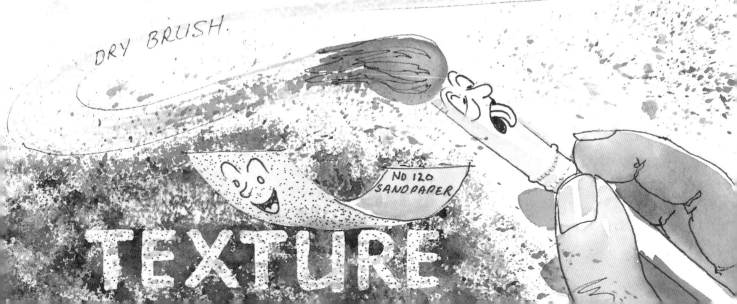

CONTROLLING THE MEDIUM

Years ago watercolor was considered a sketch medium, due in part to the lack of control many artists experienced in handling the pigment and water. Today this is not the case, as techniques have improved. So that you can work with watercolor confidently, knowing and understanding the basic methods of application is essential. Practicing with little exercise paintings will help you master the skills you need to progress to more complicated work.

WET-IN-WET
Skinny Dipping

Painting wet-in-wet means applying pigment to a wet surface, resulting in soft, fuzzy lines or shapes. This technique is often used to achieve atmospheric perspective or reduce the importance of a section in a painting.

To ensure control when you work wet-in-wet, make certain your brush contains less moisture—pigment and water—than the amount that's on the paper. That way the shapes you put down will remain fairly well defined with soft edges. If the brush is wetter than the paper, the excess paint will spread, causing the image to run out of control. If you can see the hairlines of the brushstrokes on your mixing tray, it's a good indication that the moisture content of the brush is right for wet-in-wet control.

Another important factor to keep in mind is the wetness of the paper. I have defined these three degrees: shiny wet, meaning that there is a lot of water on the paper's surface, making it glisten like enamel; satin wet, meaning less water and an only slightly shiny surface; and mat wet, meaning the paper is not shiny at all and has to be touched to determine its dampness. To see these degrees of wetness, look at the surface of the paper at an angle that catches reflected light. When you're painting, paper that is shiny wet offers no control, satin-wet paper offers some, and mat-wet paper offers the most.

There is another degree of wetness worth mentioning. If the paper feels and looks dry but is cool to the touch with the back of your hand, chances are the pigment you apply will initially form a hard line. In a short time, however, it will start to form a slightly jagged edge as the moisture wicks into the surrounding area. Sometimes this can be effective, but it is very difficult to predict.

SHINY-WET PAPER:
NO CONTROL

SATIN-WET PAPER:
MODERATE CONTROL

MAT-WET PAPER:
BEST CONTROL

RUN-BACKS
What a Blast!

The explosions that occur when a pool of pigment is left on the paper can add excitement to your painting. As the surrounding wash dries, the extra moisture in the pool creeps back into the drying area. The pool lifts and pushes back pigment, causing what's called a blossom. You can create such effects by applying a little drop of water or pigment to an area when it's satin wet to mat wet. The less moisture you apply, the smaller the blossom. The texture of the pigment governs how much it will spread. Granular pigments like cerulean blue and raw sienna do not explode as much as the smoothies. Practice and experimentation will help you gain a complete understanding of these techniques so you can use them with confidence.

If you apply pigment to a light area, you get a positive blossom—a wet-in-wet effect, as in this sketch of green trees.

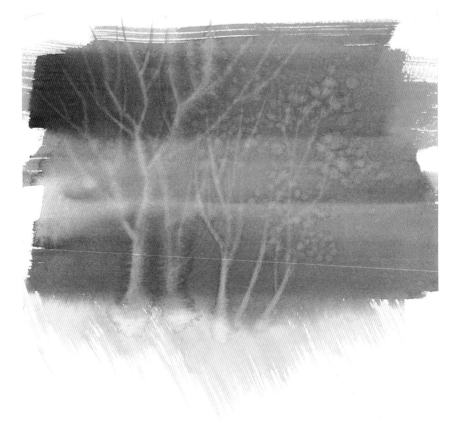

These ghostlike trees were executed in a controlled run-back. When the background wash was mat wet I gently drew the tree trunks and branches with a rigger brush dampened in clean water. To render the foliage I spattered water with a bristle brush.

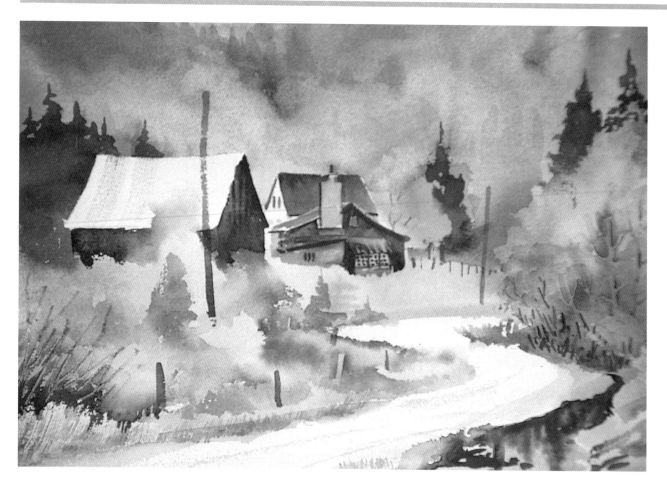

These twenty-minute sketches were done on location to demonstrate wet-in-wet and run-back techniques for a class. Most of the time was spent drying the first wash with the car heater so I could then render the hard-line detail.

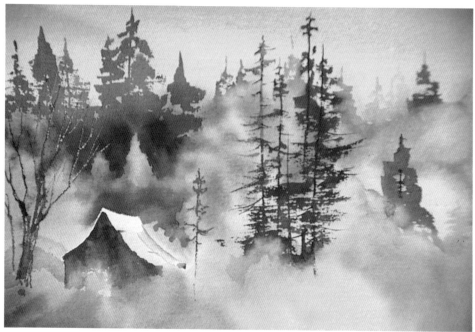

TEXTURE

There is no limit to the ways you can achieve texture with watercolor. My first preference is to use brushes.

Drybrush is one very effective technique that's easy to master. Take a hake brush that is moderately loaded with pigment and, holding it flat, apply the middle or heel section to your paper. A brush held upright in a nearly vertical position allows the moisture to flow, resulting in a solid lay of color. If your vertically held brush has very little moisture in it, however, you will get the hairline effects of drybrush.

Throughout the book are suggestions for achieving texture with other instruments and materials.

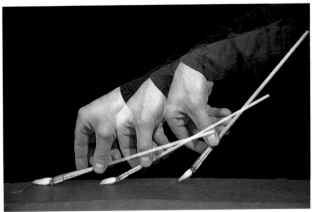

Note the way my hand holds the brush.

This study was done with three values of drybrush. For the first light value, I used a very delicate touch, keeping the brush quite flat. As I progressed to the darks, I increased the vertical angle of the brush to get more solid paint application. Hake or basting brushes are great for this technique.

A pliable piece of plastic such as a credit card (use an old, expired one so there is no problem if you lose it) works nicely for squeezing—pushing—back pigment to get natural, hard-edged texture effects. The pressure required is about the same as when you spread firm butter on toast. In this study I put down the first values of brown madder, Antwerp blue, and raw sienna on dry paper, leaving liberal white areas. When the wash was satin to mat wet, I moved the pigment around— squeezed it back—with a credit card to form the rock patterns. When this stage was dry, I defined the dark shapes with a brush.

PYRAMID OF WASHES

The layers of pigment you apply to arrive at a finished painting are generally arranged in what is best described as a pyramid, with the lightest values forming the base and the darkest forming the peak. I endeavor to achieve this in just three or four washes, leaving the white paper visible as needed. Such layering can occur in each of the different sections—background, middle ground, and foreground. The advantage of building your work pyramid-fashion is that you can plan to use the fewest number of washes (sometimes called glazes, when colors are applied over existing colors) and thus maintain a luminous quality in your painting. An excess number of washes can make a painting appear dull, overworked, and muddy. It is important to flow your colors on rather than brush them back and forth as you would with oils or acrylics.

Baie St. Paul, a small village northeast of Quebec City, is a paradise of painting subjects; picturesque 200-year-old buildings are scattered throughout the town and surrounding hills. Painting a winter scene typical of the region involved four values. Here is how I established them in different stages to arrive at my final composition.

DARK VALUES

MEDIUM VALUES

LIGHT VALUES

If you could look at a painting in cross section, you would see that the layers of pigment form a pyramid. Light values are laid down first and cover the most area; the medium and dark values that follow cover progressively smaller areas.

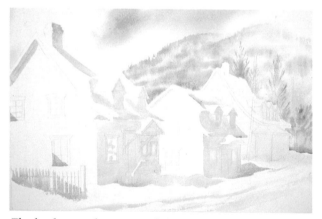

The background consists of sky, hill, and poplar trees. In the middle ground, the blue shadow is lightest in value on the most distant house and becomes slightly darker on the house closest to the foreground. In the foreground blue defines the contours of the snow. As I work my way through the painting I decide that the background and foreground washes make a statement, and that no further values are required in these areas.

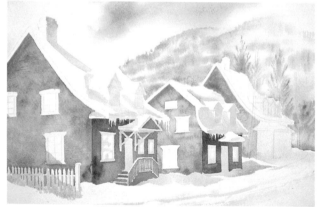

In rendering the color of the two brick buildings, I use a brighter value of red on the second house to establish its importance in the pecking order. Notice how the blue applied in the first wash creates a medium shadow value on these buildings. A medium-value wash is started on the distant house, which I have now decided will be shrouded in shadow.

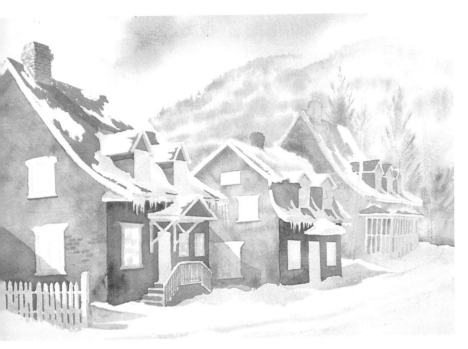

After finishing the medium value on the distant house, I apply a medium-dark value to the roofs of the red buildings. The shadows on these buildings are emphasized with another medium red value. I then apply a medium dark blue wash to the distant house, intensifying the shadow and creating more atmospheric perspective.

In the final stage, below, I add the dark values to the windows, establish a subtle pattern of bricks on the red houses to create a diagonal path of vision, and, with a bristle brush, gently lift out a highlight down the left side of the telephone pole.

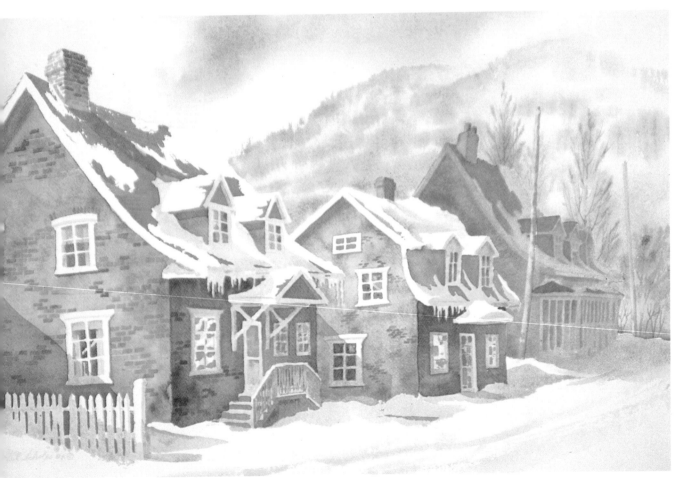

BAIE ST. PAUL, 18″ × 22″ (45.7 cm × 55.9 cm), Arches 300-lb. rough paper

MASKING FOR TEXTURE

Masking simply means covering parts of a composition to keep paint off; masking tape, paper, wax, and liquid latex are all possible materials to use. The latter two work especially well on rough or cold-pressed paper; and liquid latex applied in the drybrush method can have particularly interesting textural results.

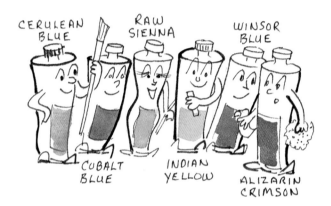

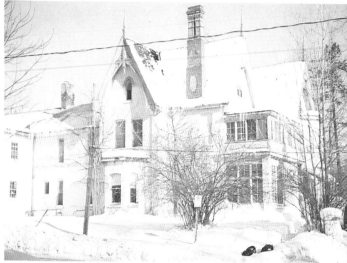

The day I photographed this building the temperature was −25°F and the air seemed to crackle. It wasn't only the house that demanded a painting but also the sky, whose cold temperature gave off a textural feeling that gave me the opportunity to try an interesting technique for capturing it. In planning the painting all I need to do is eliminate a few elements like the truck and the telephone pole and lines, as well as reduce the size of the bush in front of the house; then I start the pencil drawing.

To protect the building while painting the sky, I attach kraft paper to the watercolor paper with masking tape and cover the chimneys with tape, gently removing the excess with a utility knife. To create the texture of the sky, I dab on color with a tissue, first applying Winsor blue, then cerulean blue. After allowing this to dry, I load a slanted bristle brush first with alizarin crimson, then Indian yellow, and then Winsor blue and spatter the pigment on the sky area by dragging my index finger across the brush. Next I draw in some of the tree trunks and branches with a wax stick as a resist, then dab on Winsor blue, alizarin crimson, and raw sienna with a tissue.

Detail of sky texture.

After removing the tape and paper mask, I'm ready to start painting the building and will follow the pyramid technique to establish my light, medium, and dark values.

Before applying my first light-value washes, I draw in shrub branches along the side of the house with a wax stick to maintain whites. I then lay down a light, warm value of raw sienna and a touch of alizarin crimson for the yellow brick, dodging around the areas I need to keep white and using more alizarin crimson for the warmer color of the chimneys. The cast shadows in the foreground are cobalt blue, the only color necessary to establish a path of vision and subtle detail. Any more colors could conflict with the sky and building detail.

With the medium value I add a little more color on the chimneys and some architectural details, and establish the cast shadows on the building using cobalt blue, grayed slightly with alizarin crimson and the yellow from the first wash. Note the negative branches in shadow—the ones I drew with a wax stick prior to the first light yellowish wash.

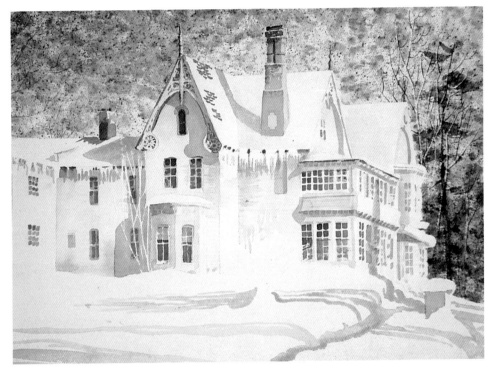

For the darks I mix Winsor blue and alizarin crimson, adding raw sienna to prevent the first two hues from going purple. I use this combination for the windowpanes, eaves troughs, and gingerbread detail on the peak of the building.

Below, I apply the final dark details with a palette knife, defining the bushes and small tree in the foreground, and branches against the sky at left.

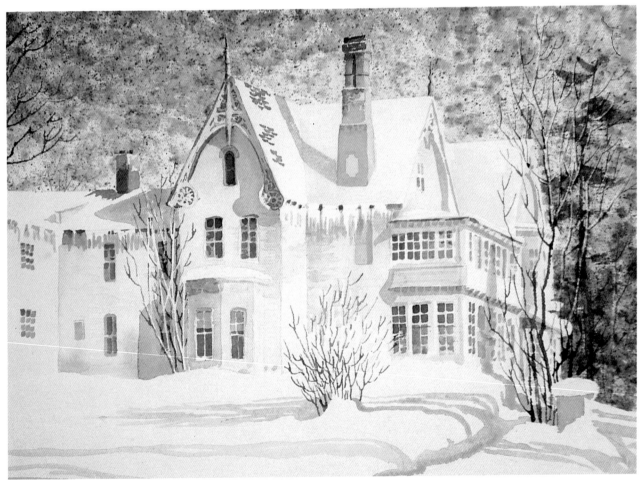

McCONKEY MANSION, 11" × 15" (27.9 cm × 38.1 cm), Arches 300-lb. cold-pressed paper

MASKING IN LANDSCAPES

Whenever you need to define texture in a landscape where accurate shapes and contours are important, masking tape is a helpful tool.

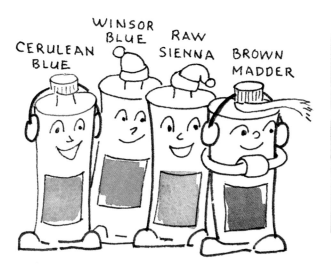

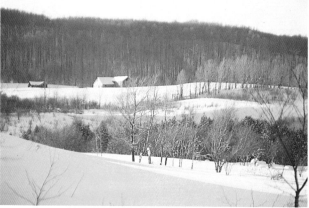

In winter Ontario's Blue Mountain is a study in rolling blue contours.

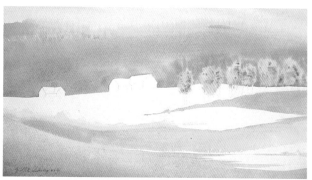

On a satin-wet surface I drop in the warm, raw sienna yellow of the trees on the distant hill and to the right of the barns, aiming to achieve soft edges. When the distant hill and sky area are dry, I rewet them and apply a wash of cerulean blue and Winsor blue with a 1" nylon bright brush, taking care to bring the blue up to and around the trees at a mat-wet stage to maintain their soft edges. As I paint the background, I create the negative barn shapes, leaving the paper dry where they appear.

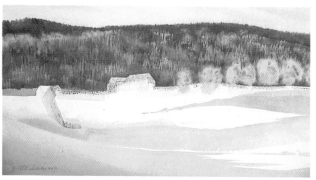

When the paper is dry, I put down masking tape along the bottom of the background hill and over the barns. Since the next step is to be painted in drybrush, there is little chance of the pigment wicking under the tape. With a slanted bristle brush (you could also use a basting brush) I work in short, vertical drybrush strokes to apply a dark mixture of cerulean and Winsor blue, plus some brown madder to gray the mix. In a few areas I blot the damp brushstrokes with a tissue to soften the lines. Dodging around the yellow middle-ground trees requires care in maintaining their soft contours.

When I remove the tape I have a crisply defined line that marks off the dark trees of the background from the white snow.

At this point I wet the midsection of the paper, from the bottom of the line of trees down to the bottom of the first blue contour, allowing the area to dry slightly until it is mat wet. I then drop in the shrubs wet-in-wet; this step is repeated for the next two contoured lines of shrubs. Raw sienna dominates, and stays in place because it is granular and heavy. Additions of brown madder and Winsor blue create the darker shrub forms.

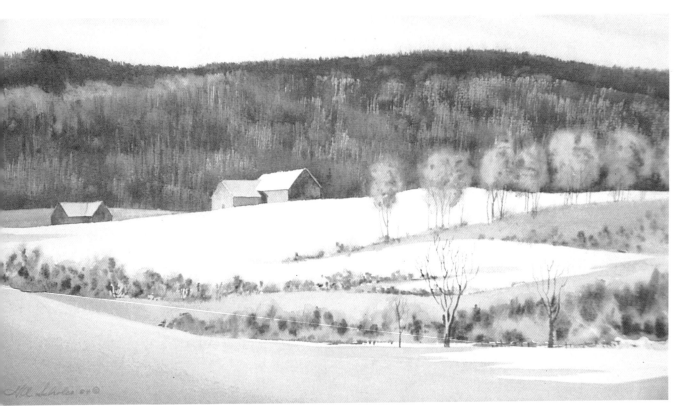

BLUE AND GOLD, 12″ × 22″ (30.5 cm × 55.9 cm), Arches 300-lb. cold-pressed paper

To finish the painting, using the same three colors I add details to the barns and the three small, bare trees nearest the foreground.

PAINTING IN SECTIONS

In this fairly advanced technique, values are handled somewhat differently; instead of establishing each one in succession over the entire picture surface, you work around the painting in small sections, completing all values area by area.

In this demonstration, without a pencil drawing or masking fluid, I put down the first wash wet-in-wet and proceeded to lay in the succeeding values in the pyramid technique. However, rather than completing all the medium values and then moving on to the darks, I finished a small section of the painting at this early stage using both values. The advantage was that I quickly established the final set of values, which then served as a reference as I worked clockwise around the painting, finishing other sections in turn.

Several Polaroid photographs give me the basis for a preliminary color sketch of my subject.

Rendering a color sketch establishes the composition and imagery for the painting. It also gets my mind on the right track so I can experiment and feel my way to the final image in a short time. This 9" × 12" (22.9 cm × 30.5 cm) sketch was completed in about an hour and a half. It started as a little exercise, but the negative and positive leaf and blossom forms moving around the central leaf pattern intrigued me, so I used it as a reference for the upcoming painting.

I wet the paper except in the areas where the white lilacs will be and where I want white highlights on some of the leaves. Using a 2" sky wash brush on a satin-wet surface, I drop in color as needed for the blossoms and foliage. In a few places where the color meets a dry area, I soften the hard line that forms with a brush of clean water. Next, using a ¾" nylon bright brush, I drop in the sprig of foliage in the bottom right-hand corner. When I move up to the top of the painting, the paper is dry, so the leaves in that area are hard-edged and in focus. I want more of the push-pull effect of lost and found edges to tie in with the blossoms, so I dry the painting completely with a hair dryer before proceeding.

Very gently, with a 2" hake brush, I rewet the areas where I want to define more sprigs of leaves. Gently is the key word here, as cobalt violet can easily lift and spread. I dab the edges of the wet area with a tissue to get an irregular wet line so a water mark will not show. I define the foliage when the paper is at the mat-wet stage to achieve softness, drying some sections by dabbing with a tissue to get a combination of lost and found edges. Then, working in the bottom left corner, I develop the details of the leaves and blossoms to their final stage using ½", ¾", and 1" nylon bright brushes. Directly above this completed section, I apply some medium values; with darks I will develop another cluster of negative and positive leaf shapes.

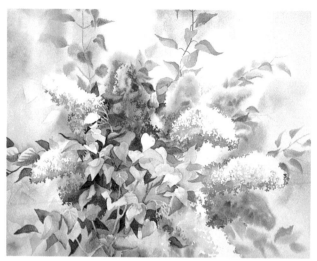

Once the left-hand side of the bouquet is finished, I sense a need for some shapes in the background, so I develop a few subtle leaf forms at the lower left. My objective is to fill the picture space with interesting design using line, space, and form in a pleasing manner. A good rule to remember is that your subject should touch at least three edges of the paper. I have seen many lovely, technically excellent renderings of flowers and wildlife that don't relate at all to a background and look like vignettes. Some artists, perhaps lacking experience to meet the challenge, don't want to chance spoiling a successfully executed subject by developing it further to integrate it with a background. I encourage you to develop images that resemble vignettes into well-designed paintings; with practice your skill at this will improve. After all, Handel didn't write the Messiah the first time he put notes to paper.

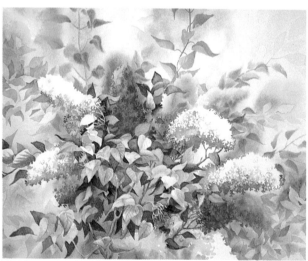

Having completed the bouquet, I work on the subtle negative and positive leaf shapes in the periphery, starting at the bottom left corner and moving clockwise. Final little touches of somewhat abstract leaf shapes in the top middle section and right-hand corner further unite the central image with the edges and background, bringing the painting to completion (right).

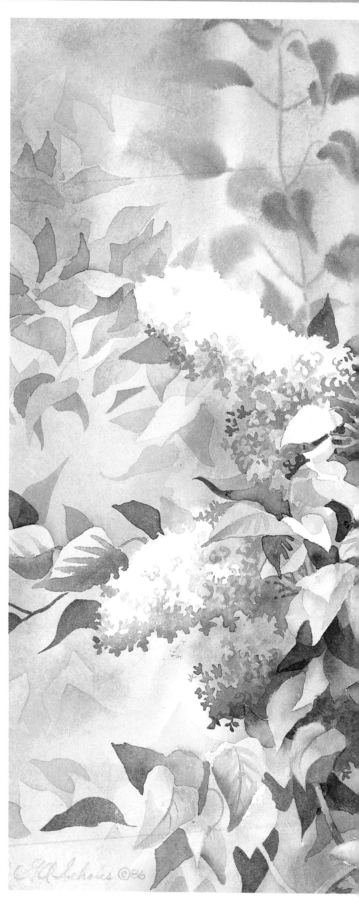

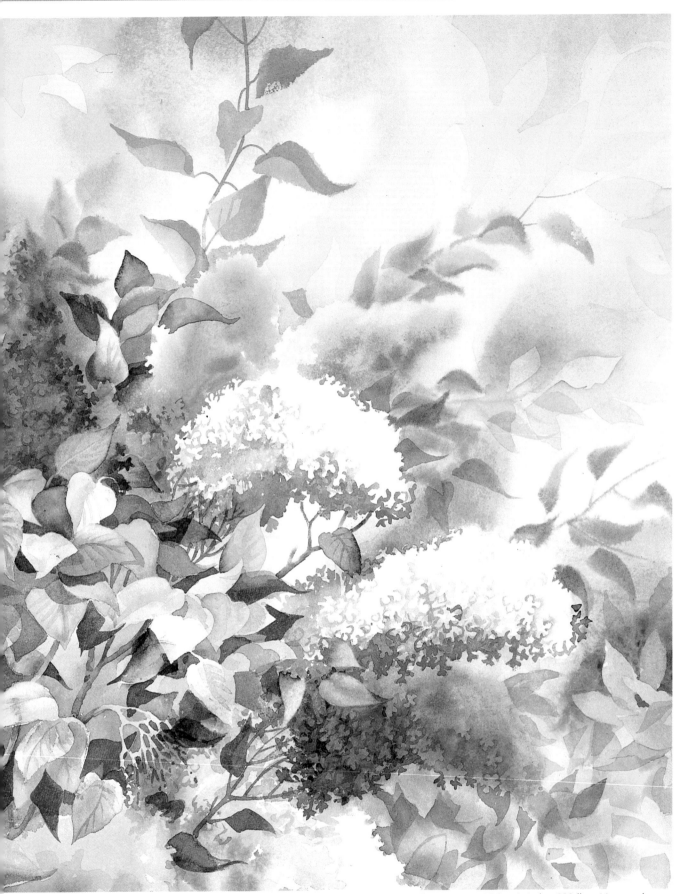

SCENT OF SPRING, 18″ × 22″ (45.7 cm × 55.9 cm), Arches 300-lb. cold-pressed paper

STAINING TECHNIQUES

Pigments that rate high in staining quality—as discussed in the section on materials—offer watercolorists certain technical advantages. Sap green is one such color. In this demonstration I mix several nonstaining pigments with it and, using a lift-off method, show how the sap green leaves traces of itself behind that let me create shapes within a dark background. You will find this approach easier than trying to dodge around such intricate negative shapes.

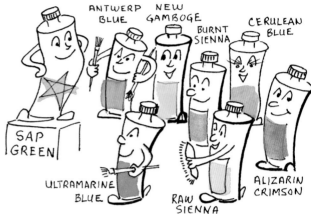

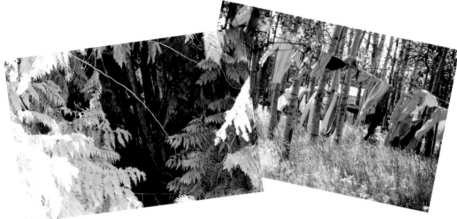

While on a workshop tour in British Columbia, Marnie and I had our trailer (we call it our 24-foot suitcase) parked beside a stand of cedar trees. I found the patterns of the hanging branches very intriguing. Later in the week I noticed a line of clothes hanging in a clearing beyond the trees, and got the idea of combining these two striking images. I had an abstract treatment in mind for the clothesline and loose realism for the cedar trees.

First I do a quick sketch to sort out some of the compositional problems. The circular foreground, three vertical trunks, and arching horizontal background of the clothesline add up to an interesting mix of line. The sketch helps me see the need to establish a pattern of shapes in the foreground that will complement the background.

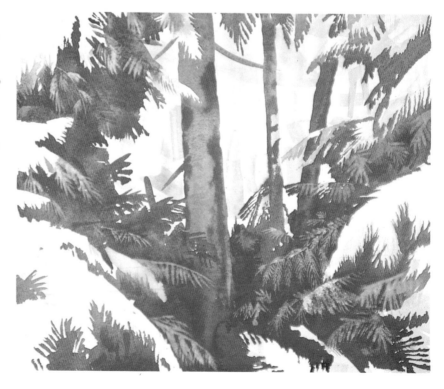

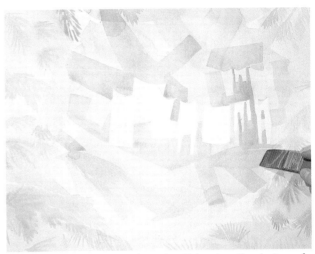

I use five colors in the first wash: cerulean blue for texture, plus Antwerp blue, raw sienna, alizarin crimson, and new gamboge. With the first four hues I develop the structure of the clothes; to establish the yellow-greens of the cedar branches, I use a mixture of new gamboge and Antwerp blue. I make sure a few of these branches are blue so some background color appears in the foreground for harmony and continuity.

After allowing each wash to dry, I develop the design of the clothes with 1½" and 2" sky wash brushes using two more glazes, cerulean blue and Antwerp blue. These values can be strengthened once I establish the foreground.

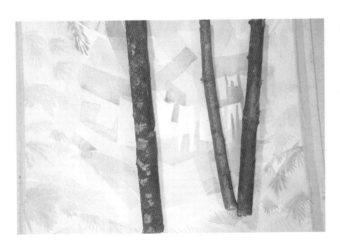

Although the sketch defined the position of the three trunks, I lay some real tree branches on the painting to confirm the best arrangement for these elements. I can then visualize the design for the wreath of cedar boughs. Another method is to paint the forms on a sheet of Plexiglas with any dark pigment, then place the Plexiglas over the painting. Mix soap with the pigment so it will adhere to this surface. I use a couple of drops of Flex-opaque, available at a graphic arts supply shop, which does a better job. This suggestion has limitless uses for determining compositional situations at any time during a painting. Here I shift the Plexiglas from left to right to consider my options.

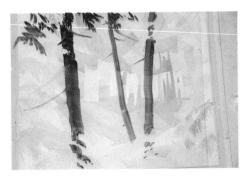

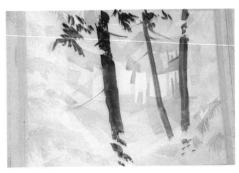

I want a combination of hard and soft shapes for the cedar branches, so, beginning in the upper left corner, I wet the paper and wait until it reaches the satin-wet stage. Then I apply a very strong mix of ultramarine blue and sap green. In some areas I apply the colors separately and allow them to flow and mix at will on the paper. I drop in some alizarin crimson in the same way with a ¾" nylon bright brush to create interesting and important touches of color amid the green foliage. I blend these colors up to the yellow branch that was established in a previous wash, and when this section is almost dry, I lift off color with my #6 bristle brush to redefine the branch shapes.

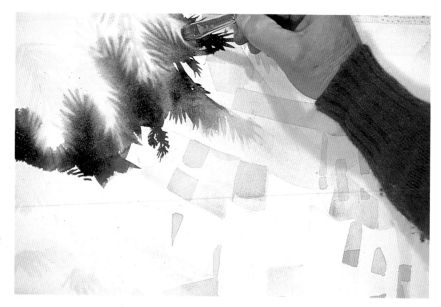

I work my way around the painting in medium-size sections using the four brushes shown here, developing the ring of cedar branches until I reach the top right-hand corner. I am careful to avoid using any sap green in the random areas of alizarin crimson and mixed light greens, as I do not want it to overpower them.

Before proceeding with any further details in the wreath, I drop in the tree trunks with a mix of burnt sienna and ultramarine blue.

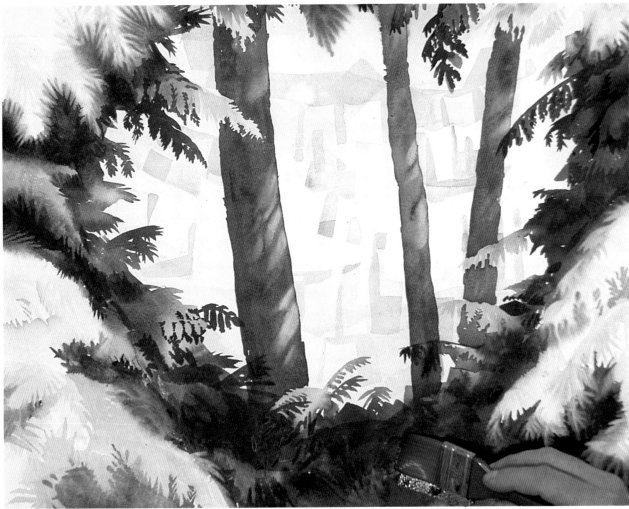

With my bristle brush I lift out the shimmer of sunlight on the trunks, then add a few cedar branches along the top edge and down each side of the wreath. At the bottom left corner I wash off some of the dark values, but the stain of the sap green remains. A glaze over the light branches at mid-left and the bottom of the wreath is needed for continuity and to tie more darks to the edges of the composition.

I use liberal amounts of sap green in the dark wash at the base of the tree trunk.

Gently manipulating a #8 round brush dipped in clean water, I loosen pigment to define negative leaf shapes.

Then I lift off the loose pigment with a dab of tissue.

Using the Plexiglas overlay again, I now aim to determine the best location of color for the clothes hanging on the line. After trying several variations, I decide on red, yellow, and blue, using deeper values of blue at this stage to strengthen the pattern.

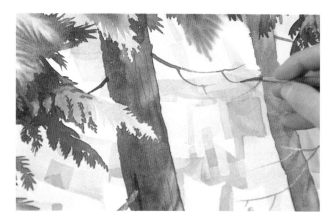

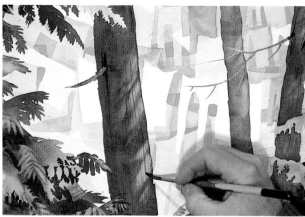

With my rigger brush I add a few dead branches and bark details using ultramarine blue and burnt sienna. As the final touch, visible in the completed painting (right), I add a light blue glaze to a small area at left, subtly defining a cedar branch that brings more blue to the foreground.

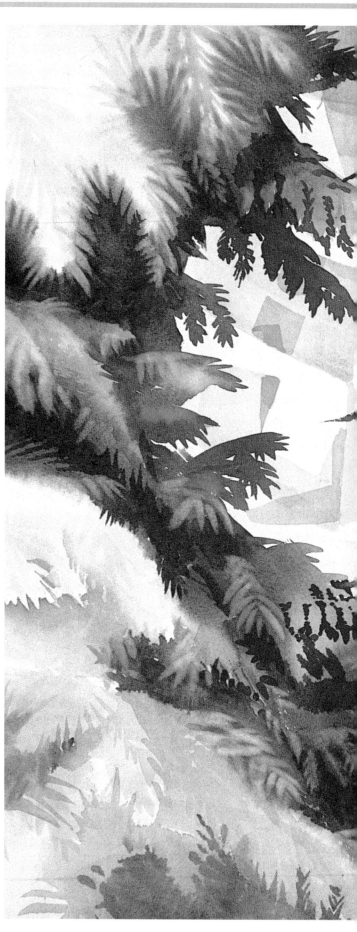

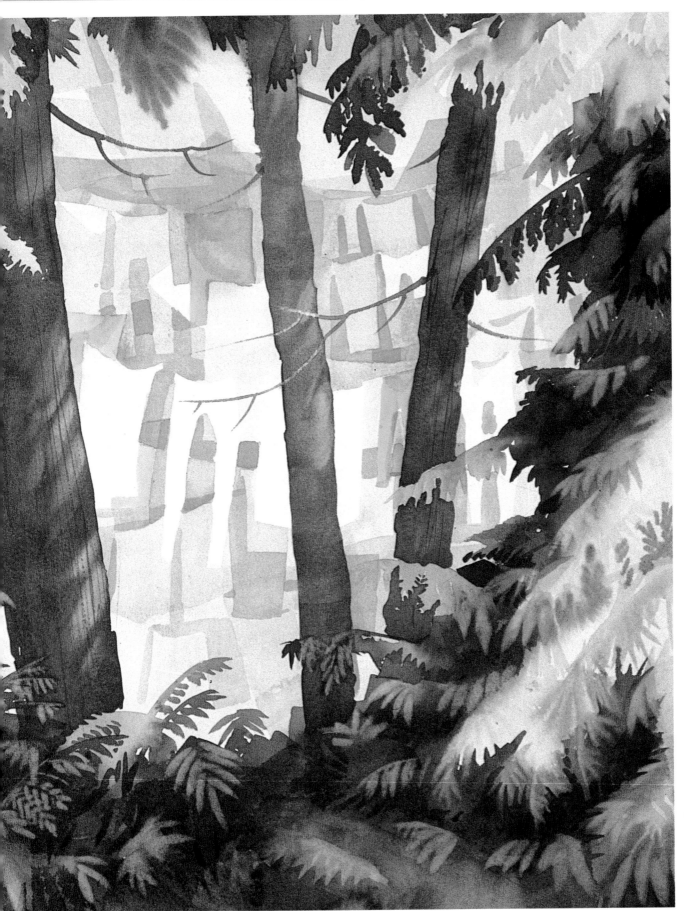

CEDAR CHEST, 18″ × 22″ (45.7 cm × 55.9 cm), Arches 300-lb. cold-pressed paper

NONSTAINING TECHNIQUES

Manganese blue has two very useful features: It is a heavy pigment and settles quickly on a painting surface, meaning that in a mixture other pigments will settle on top of it; and it rates zero on the staining scale, meaning that you can scrub it off a painting with a bristle brush. Before you go ahead and use this technique, test your paper first to ensure that it will withstand the rigors of scrubbing. If surface fibers lift off when you attempt to remove color with a bristle brush, use another paper—one with good wet strength.

Mixed with two other hues to neutralize or gray it, manganese blue is particularly useful when you want to depict natural-looking sun-and-shadow patterns on snow, which you can achieve by removing color where necessary. The knack, as this demonstration shows, is to get the right blend and apply it properly so that removing the manganese is fairly easy.

I have found that many students have trouble getting the correct combination of the three colors and keeping them well mixed before application. Another inherent problem is that once you apply the mix to the paper, it's very difficult to put another glaze on top of that layer without disturbing and spoiling it. For better success with the manganese technique, try the method shown in these next few pages. (Ultramarine blue and burnt sienna are two other nonstaining pigments that can be effective with this approach.)

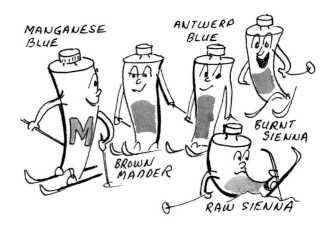

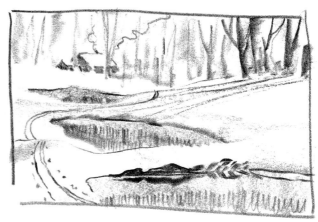

As a preliminary step I make a pencil sketch to establish the arrangement and values of shapes for a composite image of things I've seen while snowshoeing and skiing. I call this "imagineering"—calling up information that has been filed away in the brain's memory banks and using my imagination to engineer a composition from these various facts.

Instead of using pencil to establish the location of these compositional elements in the actual painting, I sketch them right on the dry paper with a rigger brush and manganese blue. (If you prefer a soft-line image, you can do the sketch on wet paper.) The amount of manganese you pick up on the brush should be just enough to let you see the image but not so much that it will dominate the finished painting—unless, of course, you want this color to be an important part of the design (in this drawing the blue is very strong so it will show up in the photograph). The beauty of manganese is that it can be removed completely with a bristle brush.

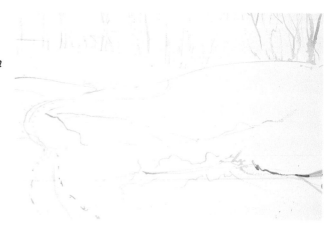

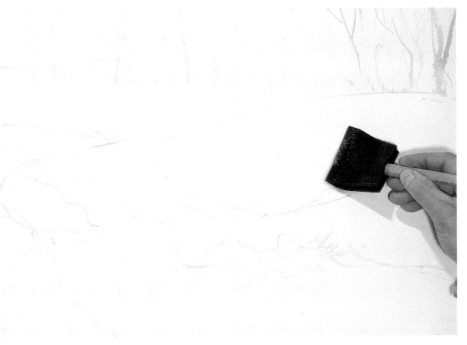

I wet the paper thoroughly with a poly brush, leaving only a narrow section dry in the foreground along the top edge of the snow on the log. Because I want the paper to absorb lots of moisture so it will stay damp longer for the next step, I don't use a hair dryer but allow it to dry back to a satin-wet stage on its own.

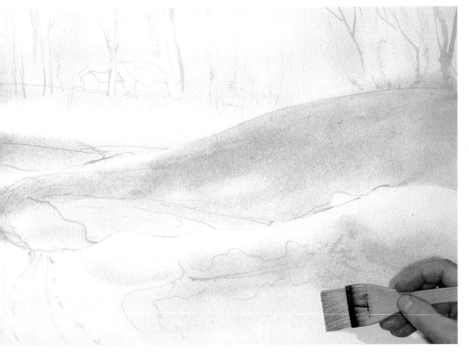

When the paper is mat wet to satin wet I apply a light value of manganese to the background area with a 2" hake brush, intensifying the color to a medium-light value for the shadows in the middle ground and foreground. To get the soft contour of the hill in the middle ground, I use very little pigment in the brush so the color won't run into the white areas. Above my hand the blue forms a sharp edge against the white of the paper, which I had left dry to get this effect and create the sunlit snowbank. The area I am painting in this step is damp so the manganese will spread downward into a soft shape; I keep the pigment away from the upper dry area. It is important to apply these washes gently so they will be easier to scrub off later. Brushing on color vigorously works the paint into the paper, making it difficult to remove.

After drying the manganese wash with a hair dryer, I rewet the paper, the same as in the first step. A medium-light value of warm gray mixed from brown madder and Antwerp blue is gently glazed over the manganese blue areas. (For greater texture you can use a mix of ultramarine blue and burnt sienna, which are more granular.)

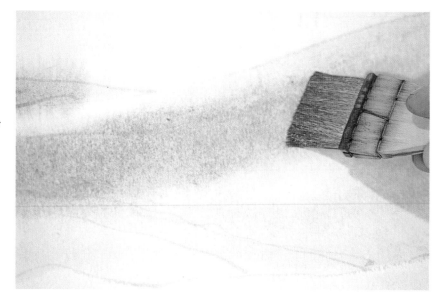

Varying the gray to create cool and warm tones gives the snow interesting hues. When applying the gray, allow some room for the pigment to migrate to the edge of the manganese blue. Start about half an inch back from the edge of the already established white areas. A knowledge of the wet-in-wet technique is important here. If paint creeps beyond the chosen area, as it has on the hill above my hand, use a damp brush squeezed dry with a tissue to pick up the stray pigment.

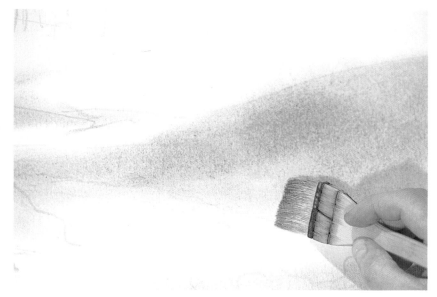

At the mat-wet stage of this wash I drop in the dark area where the snow meets the water. The shape is rendered so it represents both the shadow and its reflection at the water's edge. If the surface had dried before I was ready to add this detail, I could easily have rewet the paper about an inch above and below the area where I wanted to put down pigment to obtain the same results, without harming the existing wash. A waterline may form at the edge of the wetted area, but this can easily be removed by gently dabbing with a tissue.

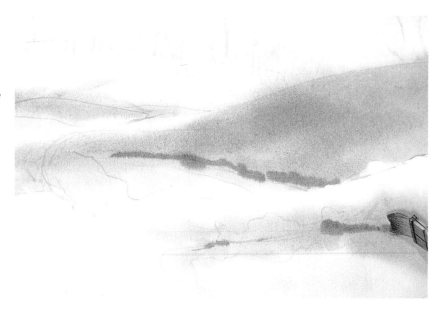

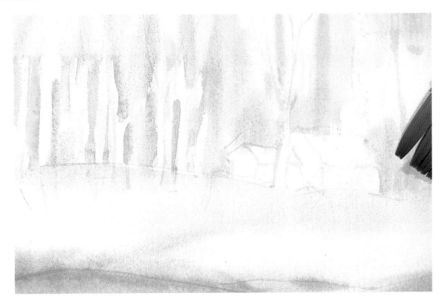

Using raw sienna and burnt sienna on my 1½" sky wash brush, I lay in the first value of the forest background. Notice the split in the brush, which enables me to develop two shape widths with one stroke. I blend the soft areas with water and paint around the shapes of the cabin and chimney smoke.

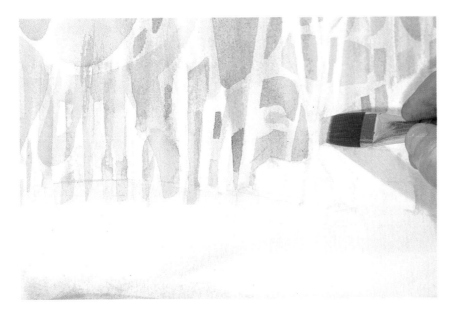

On a dry surface I define some of the larger abstract shapes within the forest, mixing brown madder with raw and burnt sienna. Notice that the manganese blue underdrawing is not interfering with the design.

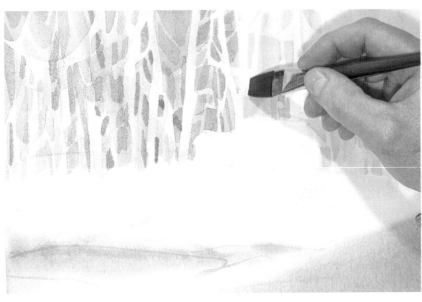

I complete the calligraphy—the intricate network of trees—by introducing some blues, a mixture of manganese and Antwerp blue with a touch of brown madder.

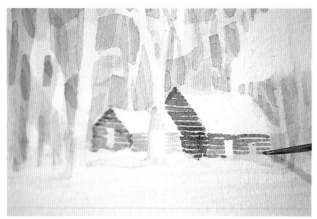

With the background value established, I drop in the log cabin, proceeding with my washes pyramid-fashion for the three values. The darkest will be the shadow lines under the eaves.

At the top right corner of the painting I render the trees with a 1" slanted bristle brush and a mix of Antwerp blue and brown madder. A ½" ox hair flat would work nicely too, using the drybrush method.

Using a damp #6 bright bristle brush, I create the pattern of sunlight on the snow by gently scrubbing off the two washes that make up the blue shadow. When removing color, apply the same pressure you would normally use when writing softly with a pencil. Blot the loosened pigment that piles up around the edges of each shape with a tissue before moving on to the next.

Here I've blotted half of one shape to show you the comparison; note the soft, diffused edges where excess paint has been cleared away. The darker spots of blue in the right-hand corner are shadow values of shrubs. I had put these down before lifting off the pattern of sunlight on the ground by rewetting the area and dropping a strong mix of the three snow colors when the surface was mat wet.

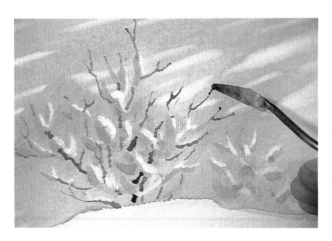

To create the white, sunlit snow on the shrub branches, I wet a couple of shapes at a time with clean water and blot each with a tissue within a couple of seconds, then remove the color with a white plastic eraser. This produces hard edges that project forward and appear closer to the viewer than the softly sunlit areas behind them. Antwerp blue and brown madder work great for the branch structure, which I apply with a palette knife.

The first value I apply to the pool is a muted blue mixture of Antwerp blue and brown madder. The value of colors I use for the reflections in the pool must be darker. When the paper is mat wet I apply these one at a time, starting with raw sienna and using very little moisture in the brush to keep the reflected shapes of the forest fairly sharp. Next I use a mix of raw sienna and brown madder. The moisture content of the paper and brush are just right for a softly defined pattern.

The secret of completing the reflections in one wet-in-wet wash is to work back and forth across the area, keeping the moisture level of the section constant. If the area starts to dry, resulting in hard lines, the best approach would be to dry it thoroughly and rewet with clean water before proceeding. Here I apply the last value of muted blues to finish the pool.

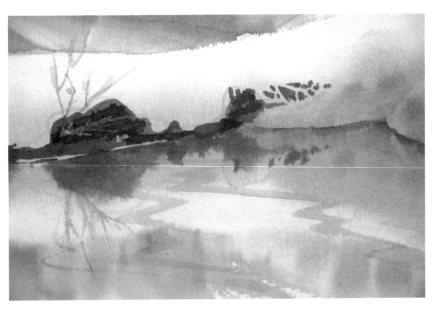

With the darks of Antwerp blue and brown madder, I complete the snow-covered log; now comes the reflection in the foreground pool. The paper looks dry but is cold to the touch—just the right amount of moisture for the pigment to creep to a slightly jagged edge in a few places. Aren't I lucky! I drop in the reflection, mimicking the shape of the log. The small shrub on the log and its corresponding reflection give the area a little more interest, while a couple of zigzags in the water (I call them "Zorro marks") provide a touch of movement.

To define the ski trail I use a #8 sable-and-nylon com-
bination round brush and a mixture of manganese blue,
Antwerp blue, and brown madder.

As finishing touches I indicate ice in the foreground pool,
creating a circular path of vision around the right-hand
corner of the painting. To recapture some whites, I
scrape the surface with a razor blade and add a little
glaze of blue near the ice to darken the water.

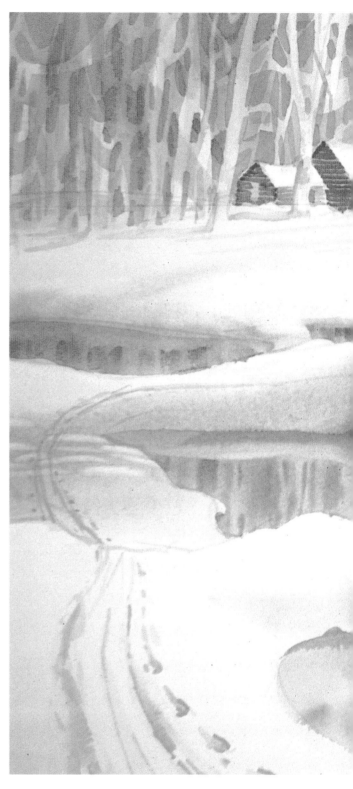

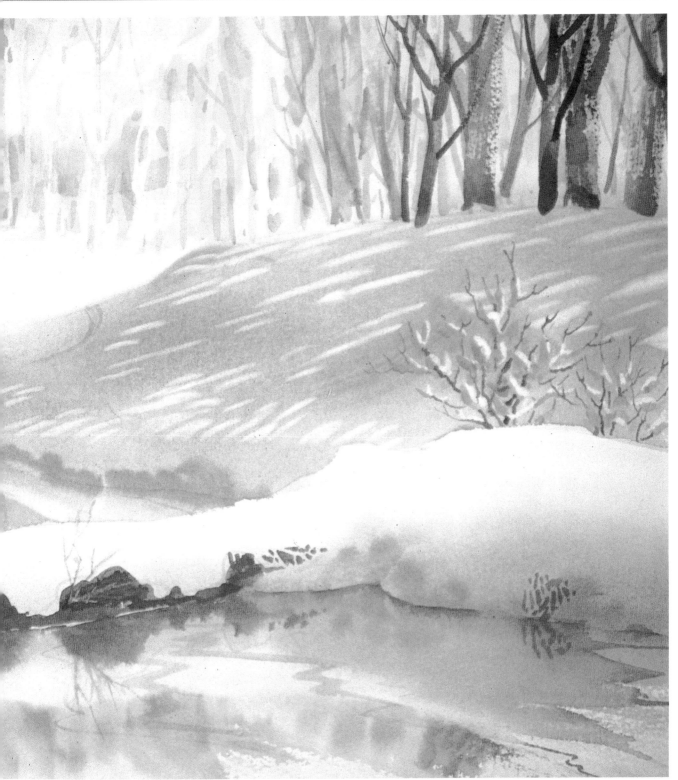

THE TRAIL HOME, 15″ × 22″ (38.1 cm × 55.9 cm), Arches 300-lb. cold-pressed paper

SEPIA STEP-BY-STEP

An interesting technique for handling close-up subjects in your repertoire is the "reclaimed lights" method, which involves the color sepia. You apply darks with this hue to establish a textured underlay, then put a juicy, medium-value wash over it and lift out highlights to create the beautiful patina of weathered wood. Masking materials are essential when you use this technique.

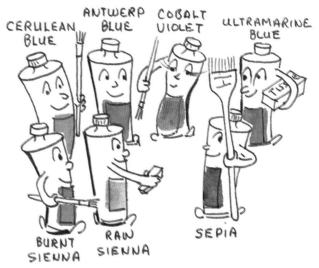

Using a black-and-white photo as my reference, I render a couple of pencil roughs to determine the composition and the location of the blue corn-flowers in my painting. I decide that the flowers should be tucked in and around the dilapidated footbridge, as their cool, blue hues will comple-ment the warm color of the wood. I pencil these in and protect most of the flowers with liquid latex. The unprotected group is just under the single blossom near the top left; I can dodge these in with a dark wash.

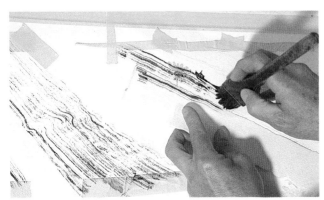

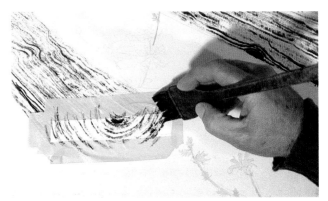

Before applying sepia in the drybrush technique, I place masking tape at the ends of the boards of the footbridge. I use a 1½" hake brush, dabbing it into a strong mix of sepia on my palette in such a way that the hairs separate so I can render the linear texture. I use a piece of thin cardboard to cover areas adjacent to where liquid latex has been applied; masking tape would stick to and remove the latex before the next step.

I use masking tape to protect the linear wood-grain texture when applying the circular graining at the end of the board, and cover previously drybrushed sections so I can apply the horizontal texture. All areas must be dry before you can apply masking tape.

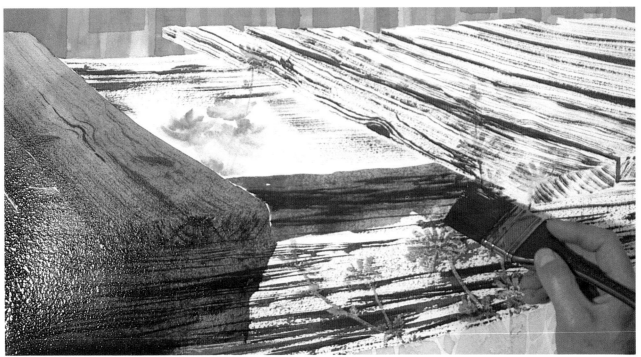

With Antwerp blue I create a vertical pattern in the background that complements the strong diagonals and horizontals of the bridge. Raw sienna is used for the grass, cerulean blue and cobalt violet for the blossoms. I now mix a generous trayful of ultramarine blue and burnt sienna to get a warm, medium-dark gray.

Students tend to mix this too light. If your mix seems to be the right value when applied to a small area, quickly darken it, as it will dry lighter and not give you the desired contrast. This juicy wash is flowed on very gently over the drybrushed wood texture with a 2" sky wash brush so the pigment is not worked into the surface.

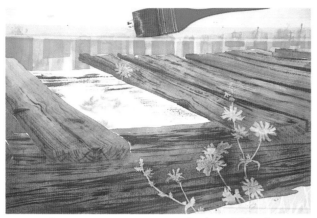

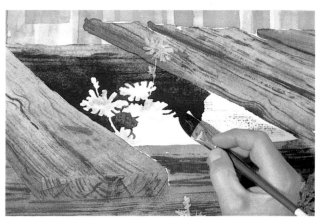

Notice the interesting variation of color within the medium-dark gray wash; to achieve this, I add liberal quantities of either the ultramarine blue or burnt sienna to the mix. On the top boards of the bridge I introduce cobalt violet, which can easily be lifted off because of its nonstaining quality; manganese blue would also work, but I want some of the violet used in the flowers to occur elsewhere in the painting.

With my ¾" nylon bright brush and a strong mix of ultramarine blue, a little burnt sienna, and some sepia, I dodge in the flowers. Flowing this wash on will prevent opacity because the pigments settle into the little valleys in the paper's surface, allowing the raised areas of its texture to show through.

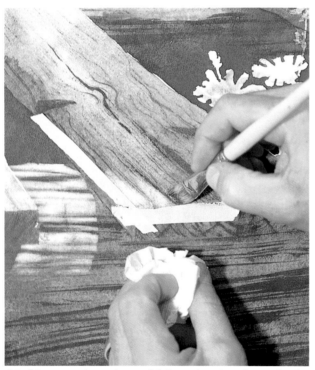

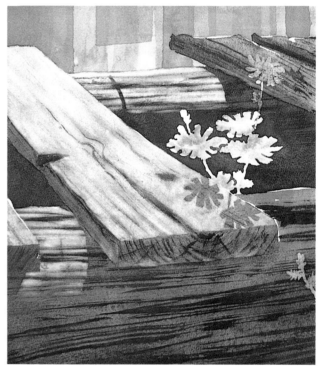

Masking tape is again useful for protecting the ends of the boards and shadow areas as I remove color with a damp #6 bright bristle brush. I remove as much pigment as possible by working in small sections, first gently scrubbing with my damp brush, then blotting the loose pigment with a tissue.

By removing the medium value, I create the effect of sunlight on this section of the bridge.

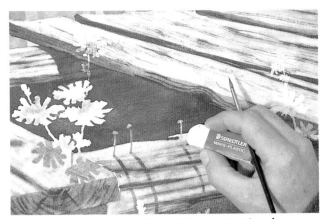

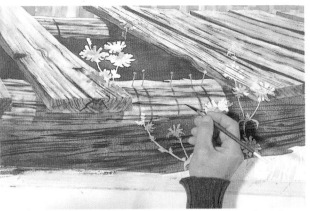

I remove color to define the nails one at a time by wetting each shape with water and a #4 round brush, quickly blotting it with a tissue and with my white plastic eraser. Burnt sienna is the perfect color for the two rusty nails at the left.

To reestablish some of the warm color removed in the scrub-off procedure, I drybrush a warm, light value of raw sienna onto the sunlit areas of the bridge. Toward the top right I apply some cerulean blue, bringing the background hue into the bridge. When this is dry, I reinstate with sepia and a rigger brush some of the larger dark areas of the wood texture that were removed and lightened by scrubbing.

I remove the latex from the flowers with a piece of masking tape, then define the blooms with cobalt violet, cerulean blue, and Antwerp blue using a #4 round brush. At this point I stand back to assess the painting. I see that the blue in the background competes with the flowers. To solve that problem, I glaze on a medium value of raw sienna, resulting in a greenish hue; then I introduce a little of this color at the bottom corner for balance, as you can see in the finished painting, next page.

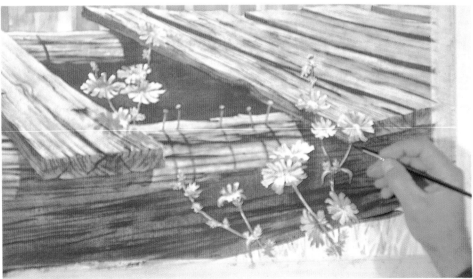

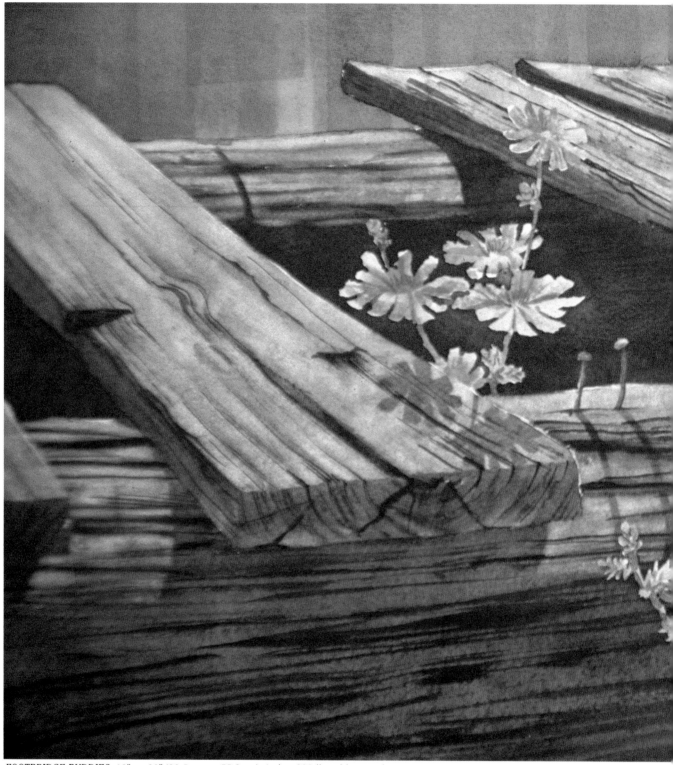

FOOTBRIDGE BUDDIES, 12" × 22" (30.5 cm × 55.9 cm), Arches 300-lb. cold-pressed paper

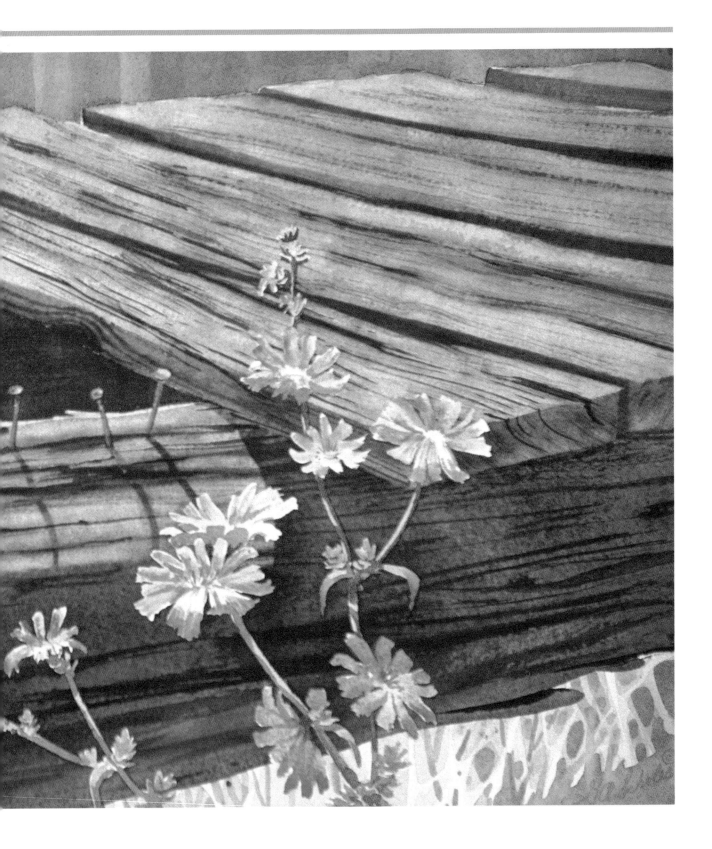

WASH-OFFS

THE SATURDAY NIGHT BATH

In this technique, you literally wash off painted areas that have dried to reduce and smooth out the color, then apply further glazes over these same areas. This allows you to maintain luminosity in your work and prevents washes from becoming muddy.

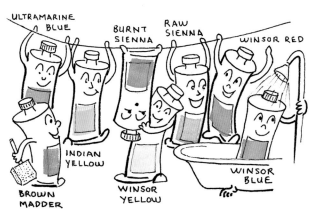

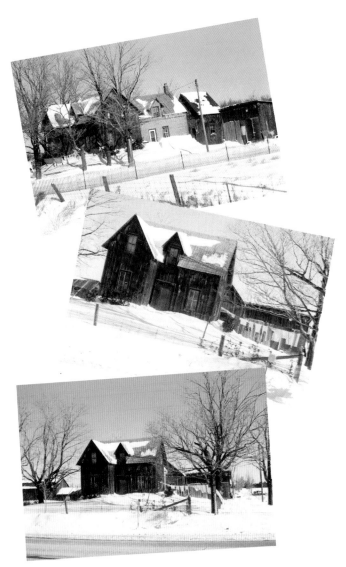

These photographs reacquainted me with this board-and-batten house near Ottawa, a subject I discovered one Monday in March. I often shoot photos of my subject from different angles to get other dimensions; here, the shot of the opposite side of the buildings is a bonus, as I will eventually use it for another painting.

Knowing in my mind how I want to handle the painting, I do not do a thumbnail pencil sketch first, but go ahead and draw the buildings right on the watercolor paper using an HB pencil. Before touching brush to paper, I spend a little time thinking about the pattern of shapes that will make up the chimney smoke and tree branches. I also try to squelch the intimidation caused by that lovely white piece of watercolor paper.

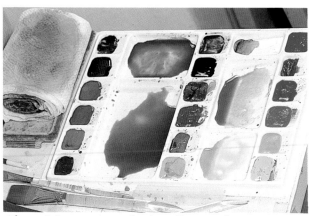

After mixing my tray of colors, I am ready to start.

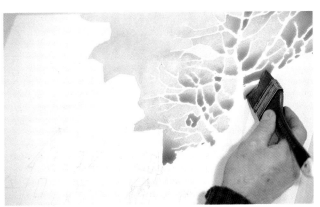 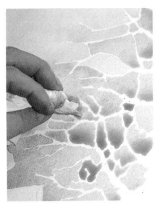 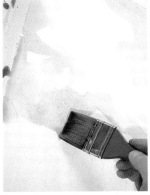

With a mix of Winsor blue and a touch of Winsor yellow I put in the sky, forming the shape of the smoke. I take care to make sure that the various angles and shapes are not in competition with one another. Arriving at the outside edge of the tree, I define its branches by painting negatively. I use a 2" sky wash brush to ensure that I do not get fiddly at this early stage. The brush is kept loaded so each section goes on very juicy.

I wick up the pools of liquid that form by just touching the area with a damp tissue. I do this several times as I progress with rendering the tree branches.

Carrying a juicy wash enables me to change a shape and modify color easily. Adding raw sienna with a touch of brown madder low on the horizon finishes the first wash. Then I dry the painting with a hair dryer.

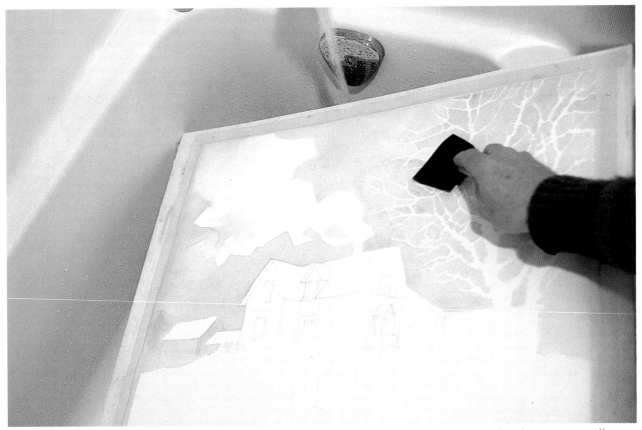

Taking the painting to the bathtub, I wash off all the color I possibly can with a poly foam brush. A sponge will also work.

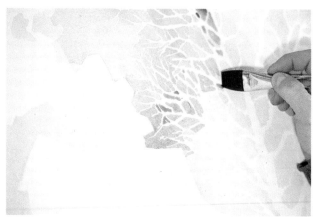

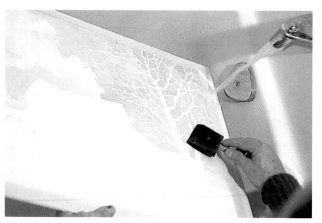

I then glaze over the first wash, building the branch structure and smoke pattern by repeating the same colors and values of the first paint application. This time I use a 1" nylon bright brush to accommodate the smaller shapes.

Here I wash the painting off again.

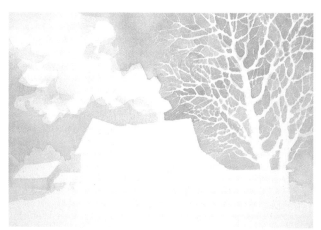

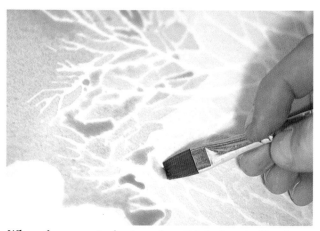

The washing-off process reduces and smooths out the color, ensuring that the painting will stay luminous even as I apply more glazes. When you use this technique you can avoid scumbled and muddy washes.

When the paper is dry I apply a third glaze to the sky, using the same color and value as the first two. I work with a ½" nylon bright brush as the areas grow progressively smaller.

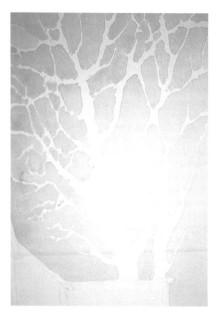

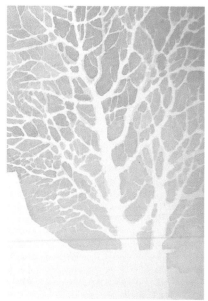

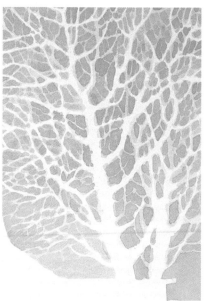

In this comparison you can see how the branch structure has developed in each of the three glazes.

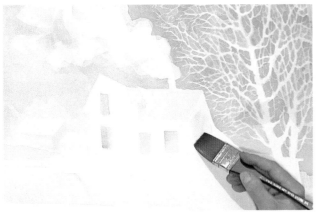

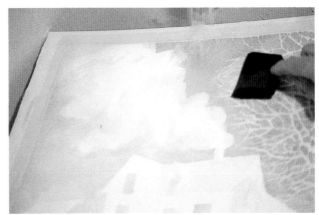

I now apply bold patterns of Winsor red and Indian yellow with a 1½" sky wash brush, laying the colors down pure in some places and mixed in others, creating warm sections in the tree, smoke, and foreground areas. The reflective color in the windows is dropped into position.

The third and final wash-off is done at this stage.

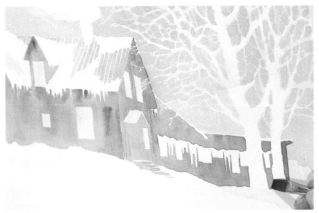

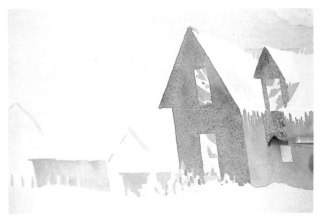

I use the pyramid method to apply the colors of the buildings. Burnt sienna, brown madder, and touches of ultramarine blue make up the first wash on the house; for the grays on the sheds I use greater amounts of ultramarine blue, dodging around the line of clothes as I work.

The next value forms the shadow areas of the buildings, which I achieve with a glaze of ultramarine blue for texture and Winsor blue to reflect the color of the sky.

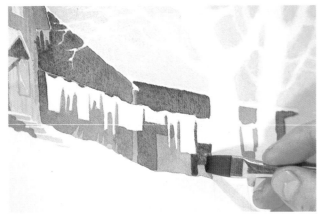

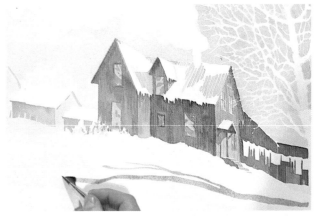

A final, cool gray glaze of ultramarine blue and burnt sienna is applied to the sheds.

The shadow on the snow is mixed from the same colors I used in the shadows of the buildings, again picking up the hue of the sky—the source of the shadow color.

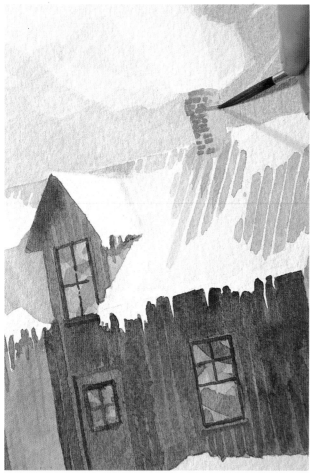

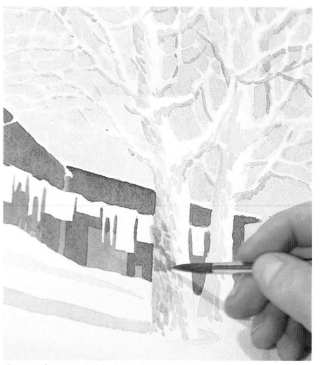

Once I have established the darks of the buildings, I can lay in the values of the trees pyramid-fashion. The first value is a mix of raw sienna and burnt sienna; here I've started to put down the second value, which is slightly darker than the first.

The third value of medium darks for the side of the house, a mixture of ultramarine blue and burnt sienna, is applied with a ½" nylon bright brush. I flow this on so that the existing colors won't be disturbed, and so that I don't spoil the board-and-batten pattern or the patina of the wood I've already achieved. Next I work on the windows, where the abstract shapes make interesting reflections. I enhance these with glazes prior to proceeding with the darks of the window frames. Then, using a rigger brush, I define the darks around the windows and a few bricks on the chimney.

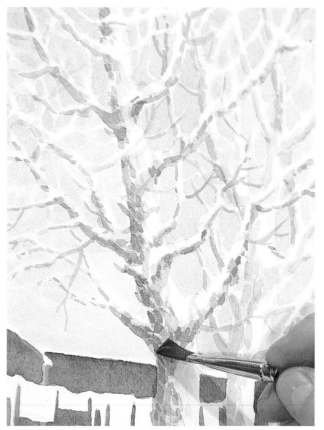

When the trunk and branches are finished, I glaze on the shadow pattern using the same blue color of the buildings.

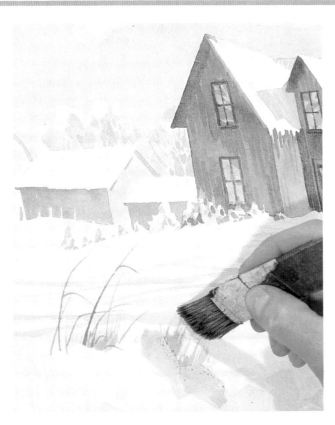

The bottom left corner of the painting cries out for a path of vision to direct the viewer's eye up to the buildings. To solve the problem, I paint in a few weedy growths with raw and burnt sienna, using masking tape and a slanted bristle brush, as well as a rigger brush for the tall "growies." I also render a few shapes in the trees behind the barns to give this area a little interest. These sections have to be subtle so as not to draw too much attention toward the edge of the painting.

At this stage I have a cup of coffee and assess the overall painting (below). I decide that the smoke allows the eye to run out of the picture too easily.

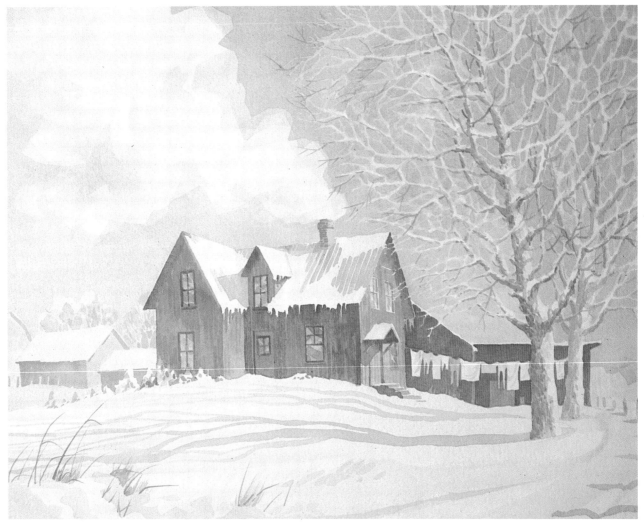

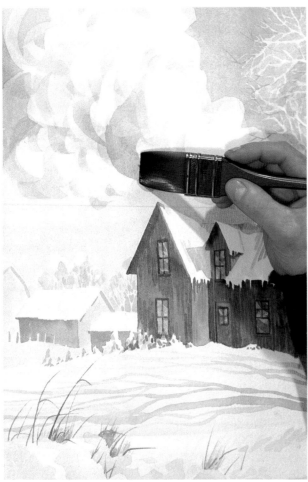

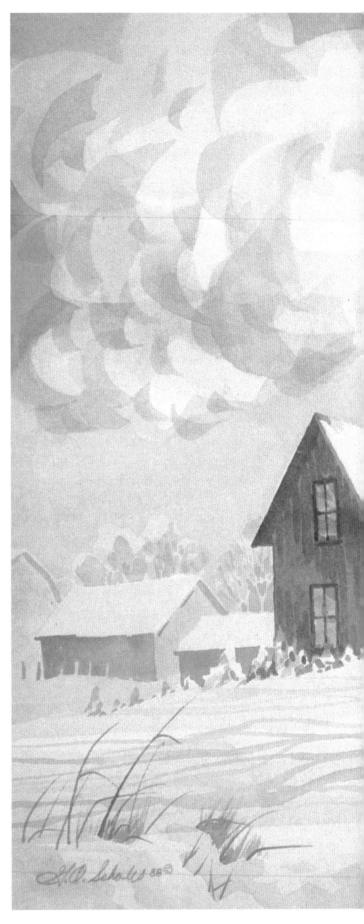

Applying more shapes to the smoke in the top corner creates shadows that provide dimension and direct the eye around the corner of the picture. The smoke forms harmonize with the branches on the right side of the composition. After adding the extra values to the left side of the painting, I see that the tree branches need reds and yellows for a little more weight. Throwing caution to the wind, I drop in more color. It looks right to me, and I call the painting complete.

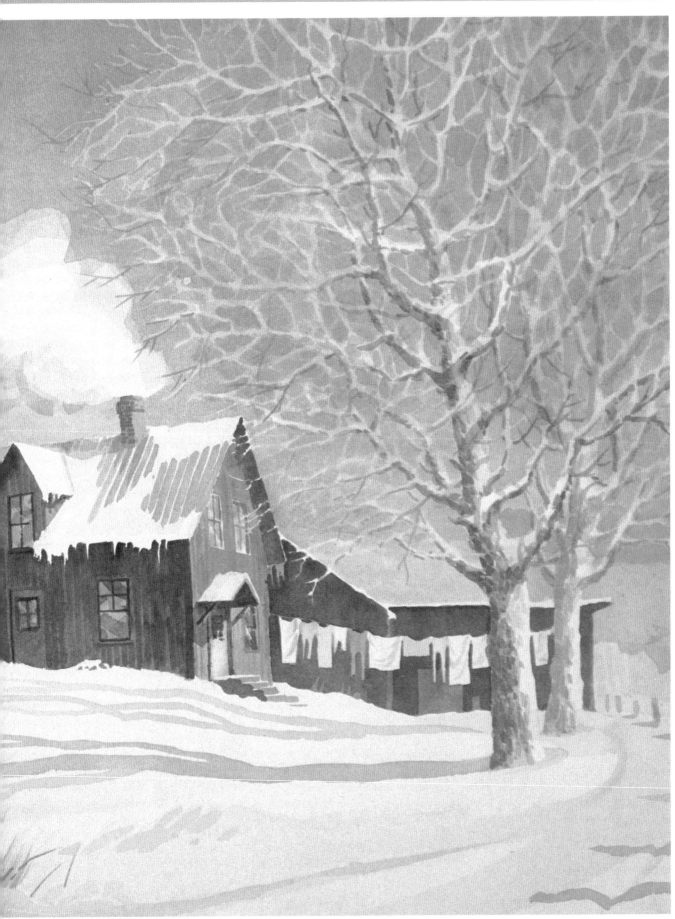

MONDAY IN MARCH, 18″ × 22″ (45.7 cm × 55.9 cm), Arches 300-lb. cold-pressed paper

PAINTING REFLECTIONS

Reflections of objects in water are perceived as being difficult to paint, particularly if there is any wave action that distorts the image. The best way to analyze and learn to handle reflections is to use photographs. Squint at a photo so you see only the bold shapes, then paint them, starting with the lightest value. Don't be timid, and don't overwork the reflections, or you'll get muddied results.

The chart shown here is a guide to the reflected value of an object; values are rated on a scale of 1 (the lightest) to 10 (the darkest). The painting of the boat below illustrates what the chart explains. The reflection of a light object will be one, sometimes two values darker than the object itself; in the painting, note how the boat's sunlit white hull reflects blue. The reason for this is that the local color of the water influences the color of the reflection, darkening it. When an object is in the middle value range, its reflection can be the same value, but sometimes a slight change of color is effective. Note how the side of the boat in shadow has a reflection that is nearly identical in value. If the object is dark, the water's color causes the reflection to be lighter; note the reflection of the dark piling at right. This is caused by light bouncing off minute particles present in the water. Keeping these principles in mind should make it easier for you to determine reflection values.

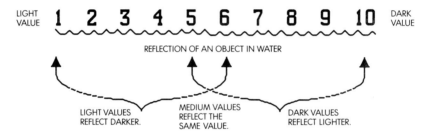

VALUE SCALE OF AN OBJECT ON WATER

LIGHT VALUE 1 2 3 4 5 6 7 8 9 10 DARK VALUE

REFLECTION OF AN OBJECT IN WATER

LIGHT VALUES REFLECT DARKER. MEDIUM VALUES REFLECT THE SAME VALUE. DARK VALUES REFLECT LIGHTER.

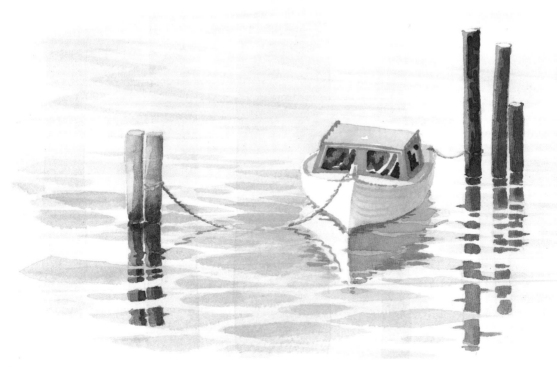

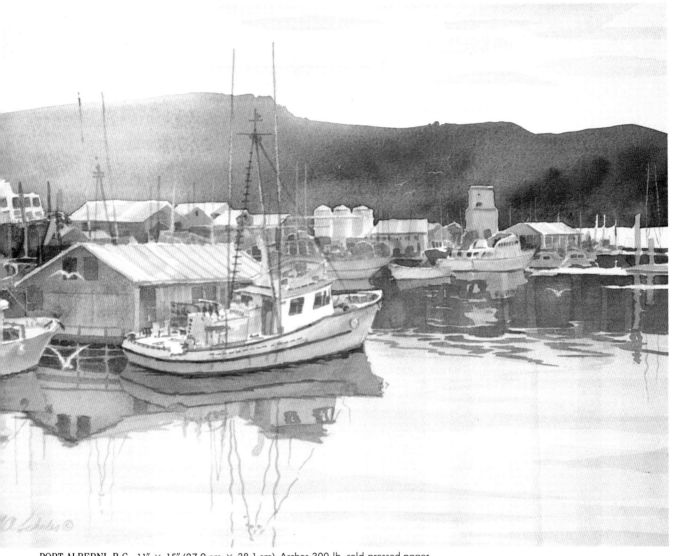

PORT ALBERNI, B.C., 11" × 15" (27.9 cm × 38.1 cm), Arches 300-lb. cold-pressed paper

The reflection is divided into four major sections. The sky is the lightest and reflects marginally darker in the water; the green boat, also on the light scale, reflects darker; the warm-colored shed is a middle-range value and reflects almost the same value; the distant mountain at right is a dark value and reflects lighter in the water.

PAINTING MOVING WATER

Moving water, with its ever-changing patterns, may at first seem difficult to paint but in reality is quite easy to handle if you follow a few basic rules, as this demonstration shows. When observing water flowing over or around a rock, fix your eye on one spot and don't allow it to follow the motion. By looking at one spot, you will begin to see a repeating pattern of shapes; blinking your eyes very fast creates a slow-motion effect that also helps. It is these shapes that, when rendered, capture the essence of flowing water. When you paint the shapes, keep a liberal amount of soft line, blurring the forms to give a sense of motion. A lot of hard, crisp lines tend to stop the motion, and can make water look like ice.

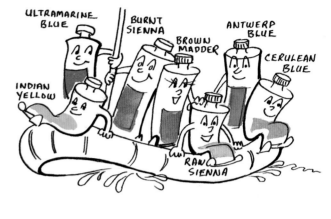

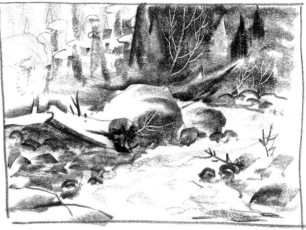

In this quick pencil sketch, I did some "imagineering" and united the two scenes.

These photographs were taken in Yoho National Park in the Canadian Rockies, where my wife and I took an hour's hike up a mountain trail to see an unusual rock formation known as the Hoodoos. Distance and time did not allow me to lug my painting equipment, so a camera was the answer for collecting reference material. The rock forms were situated 100 yards farther up the mountain from the bank of Hoodoo Creek.

Since the perspective is not complicated, I proceed without the use of pencil lines. On dry paper I apply the first wash of raw sienna, with touches of Antwerp blue and brown madder, to define some of the Hoodoo rock forms.

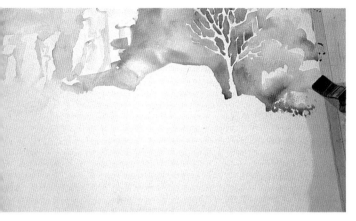

After drying the first section, I add more Antwerp blue to the raw sienna and burnt sienna and define trees to the right of the Hoodoos. I vary the color through this area, introducing cerulean blue and stronger touches of brown madder. To ensure that the branch structure remains bold, I continue to use my 1½" sky wash brush and paint the spaces between the branches. With Indian yellow I render round shapes on the right side of the painting. These are needed to break up the static, linear forms of the Hoodoos and branches. I will have to be careful to move the green area next to the Hoodoos over to the left, as it now divides the painting in half, and the negative tree is centered within one of these two equal spaces. I will attend to this later, as I am anxious to give some form to the rushing water.

Using the drybrush technique, I stroke on a mix of Antwerp blue and some cerulean with a 1" filbert brush, creating long, soft- and hard-edged oval shapes that follow the motion of the water. In my left hand is a brush dipped in clean water, which I use to soften some of the forms and create a sense of movement.

Once I establish the bend in the stream, I introduce raw and burnt sienna, starting at the top of the creek. This medium value gives the water more color and helps unify this area of the painting. The paper is still damp in places where the first value was put down, so adding the medium value is just a matter of touching the pigment to the surface and allowing it to flow. I keep my water brush close by if I need it to soften any forms. If an area has too many soft forms, dabbing with a dry tissue will reestablish some hard edges.

Continuing with ¾" and 1" filbert brushes (a full-bodied brush like a large round or 1" hake would also work), I tackle the three large boulders next. To break up the monotony, I drybrush a warm value on the one at left and let gray-blues mixed of mostly cerulean blue with touches of Antwerp blue and brown madder dominate.

I apply the second value in the drybrush technique using the same color as the first, dabbing the rocks with a dry tissue to achieve texture.

Before rendering the darks, I warm up the center boulder with a drybrush application of raw sienna. Then I use a warm, dark hue to create a small negative bush form, and add cool darks on other parts of the boulder. The drybrush is very effective for depicting the areas where the water splashes along the edges of the boulders.

Two strokes of raw sienna and burnt sienna with a basting brush create the linear texture on the large log. A hake or slanted bristle brush would work well for this too.

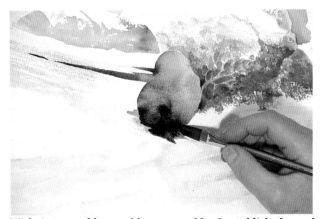

With Antwerp blue and brown madder I establish the end of the log.

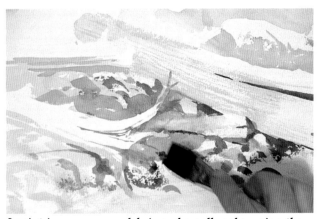

I paint in some more debris and small rocks, using the same four colors and procedure I used for the larger boulders. This defines the edge of the stream. Here I start applying the darks over the dried light values.

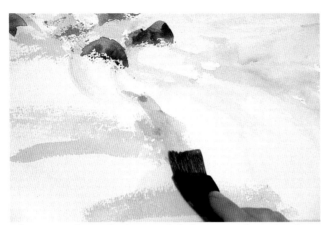

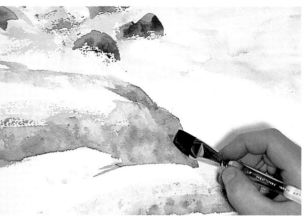

The two rocks in the bottom left foreground receive the first value of raw sienna. Notice how the little rocks above this area are nestled in the water. I purposely made them greenish to bring some of the background color into the foreground.

The final greenish value is applied over a little section of the drybrush-textured rocks.

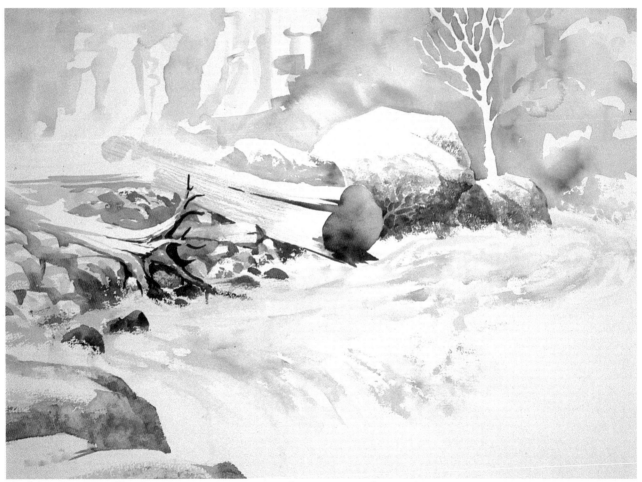

At this point I stand back to assess my progress, and decide that I dislike the intensity of the negative white tree trunk that comes down behind the boulder in the middle ground. I will change this later by scrubbing off the surrounding color and dropping in a bush. Now I can either render the rocks in the open space at right, or develop the Hoodoos and trees in the background. Which shall I choose? Right! I'm going to do the background, since I have sufficient darks in the middle ground to arrive at the proper background value.

With a warm medium value mixed with cerulean blue, raw sienna, and burnt sienna, I define more Hoodoos in negative and positive forms. For the shape in the sky I use a slightly grayed mix of Antwerp blue and brown madder, intensifying the color to further define the top of the log and Hoodoos. It is now time to turn my attention to the green tree line and move it off center in the composition. To do this I develop the little fir trees as simple, abstract triangles, mixing Antwerp blue and burnt sienna for the green and adding ultramarine for more blue.

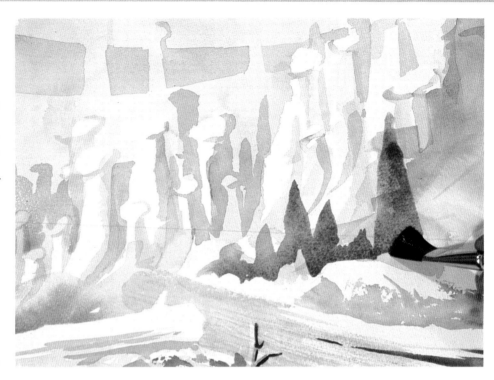

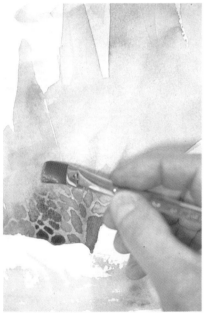

When the fir trees are dry, I load a #8 round brush with a strong mix of the same colors I used for them, and define the branch structure of a small shrub by painting negatively. Note that I make use of the warm color that's already there. Using a ½" nylon bright brush dipped in clean water, I soften and blend the outside edge of the dark shapes into the background color.

The combination of fir trees and circular bush shapes creates an interesting mix of line, space, and form; I carry these abstract elements all across the background area to complete this section of the painting.

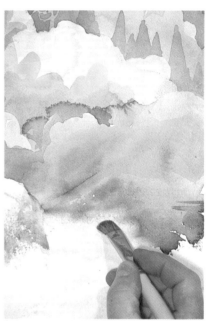

Now it's time to pay attention to the water again. I see that the hard-edged drybrush effect where the stream comes out from behind the boulders would be better as a soft line; this would help set the stream bank back into the distance. Scrubbing gently with a #6 bright bristle brush does the trick.

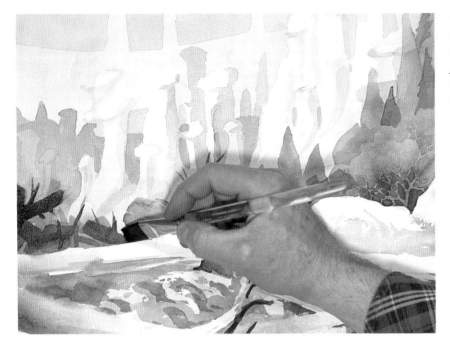

This area is now dry, so some logs and debris can be defined. I use ultramarine blue, placing these objects in cast shadow. The strong contrast between light and dark values creates a dramatic effect..

To remedy the problem with the white tree trunk I mentioned earlier, I remove as much color as possible with my bristle brush and then apply the bush shapes in front of the tree with a couple of glazes.

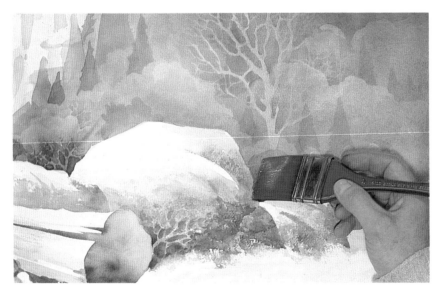

The chroma—purity of color—in the background trees is too intense, so I apply a glaze of ultramarine blue, thus creating a better sense of atmospheric perspective.

In the pencil sketch that appears at the beginning of this demonstration, the dead tree trunk is set back from the stream's edge. As I was defining the bank in the painting, however, I decided it would cause too strong a path of vision across the composition, so I rearranged the elements and brought the log out. Here I am adding a rock to support it in the water.

While the rock is still damp, I use my palette knife to sprinkle salt along the edge where the water hits it to create a splashing effect.

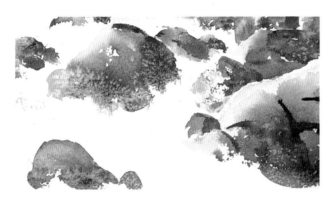

I render a triangular group of rocks midstream in a light value of raw and burnt sienna, dropping touches of ultramarine blue into these wet areas and allowing the color to flow at will. When the rocks reach the mat-wet stage, I again sprinkle salt into a few areas. To finish the section I add a few darks.

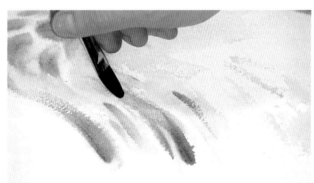

Before I begin to depict a fast-flowing pool and small falls in the stream, I wet the paper and wait a couple of minutes to allow the moisture to penetrate. Then I pat it with a tissue to remove the excess water. With a dry brush I pick up strong pigment and render oval shapes. When I can see the hair lines my brush makes on the plastic mixing tray, I know I have the right amount of moisture and pigment to achieve the wet-in-wet effects I want. To depict the water flowing over and down the falls, I start some of the brushstrokes at the bottom and draw them upward, as I am doing here. My colors are Antwerp blue, ultramarine blue, and burnt sienna. At this stage I'm getting almost a drybrush effect, so I soften an edge or two with water to maintain the stream's motion.

Adding raw sienna to the colors I used in the previous step, I create the foamy splash at the bottom of the falls with a basting brush (a hake would also work here). I am using the heel of the brush, moving it in a circular motion back and forth across the area. With each pass I introduce a little darker value and dab with water or tissue to soften some sections. When I am satisfied with the look of the splashing water, I sprinkle some salt into the area to enhance the effect.

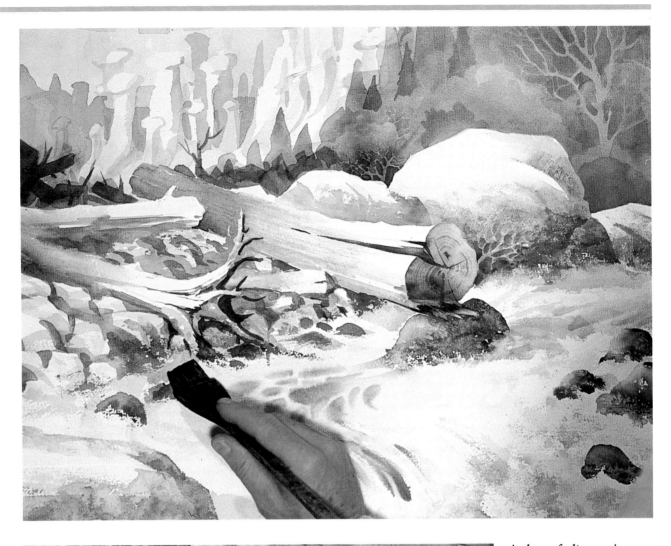

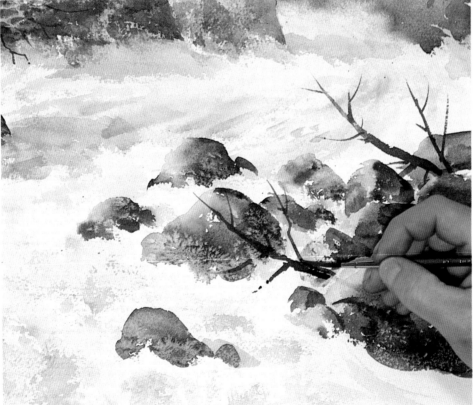

A glaze of ultramarine blue along the stream edge and into the water defines a shadow cast on and by the rocks, boulders, and logs.

A rigger brush is my favorite for defining little shrubs and branches.

The technique I used to depict the water in the upper pool works here, where the falls drop into a deep pool. To ensure that the shapes don't spread but remain as I've put them down, I quickly dry the area with a hair dryer.

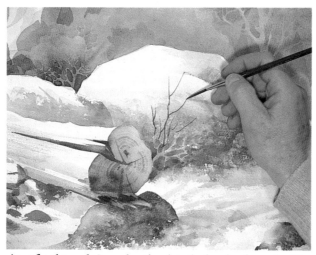

As a final touch I render the detail of a shrub, and with that the painting is done. That 1,000-foot hike up the mountain was worthwhile! The painting captures the mystic quality of the Hoodoos in their majestic setting and the mesmerizing effect of the glacial blue mountain stream tumbling over the bric-a-brac of logs, polished boulders, and rocks.

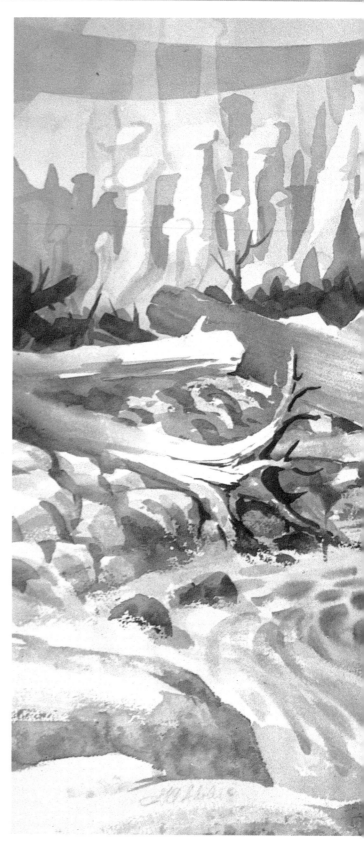

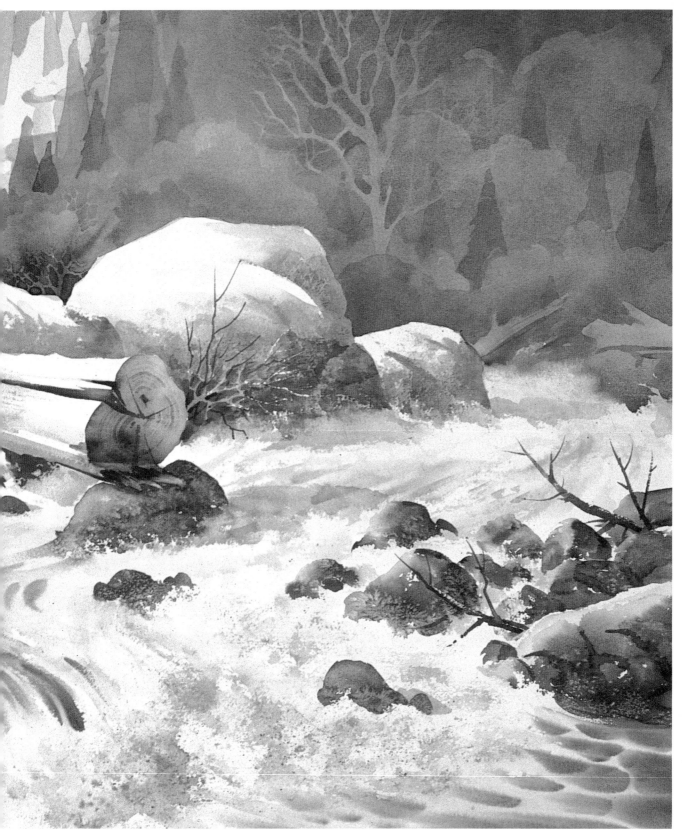

HOODOO CREEK, 22″ × 30″ (55.9 cm × 76.2 cm), Arches 300-lb. cold-pressed paper

NEGATIVES
The Positive Way

Because one object of working in transparent watercolor is to preserve whites and light values, painting negatively is an important skill to master. "Keep it simple, student" is the best advice I can give you when you start painting negative forms. Look at the shapes beyond an object; when you render them, the object will materialize. Exercises like this will sharpen your skills. Can't you just hear these little characters saying, "Eat your heart out, liquid latex!"

SEEING NEGATIVE SHAPES

Working with negative shapes is one of the greatest challenges in transparent watercolor painting—the challenge of planning compositional areas that are to remain white or light values and maintaining them as you progress to the darks.

When teaching watercolor, I have found that students seem to have the most difficulty mastering the skill of working with negative shapes. It requires being able to see not the object itself but the shape and space around it. When you look at a tree, for example, pay attention to the spaces between the branches and you'll see a combination of square, rectangular, rhomboid, round, oval, and triangular shapes. Render these to create the branch structure. The point is to train your eye to see the shapes that make up any object.

That's easy to say, but how do you start? Simply. You can't hope to achieve satisfying results by rendering a very complex subject. To begin, limit your palette to one color such as lamp black or sepia, and look for simple subjects—clothes on a line against a dark background, a white picket fence, a few leaves and branches. As your abilities improve, paint a sunlit, leafless shrub, a tree, then two trees, and so on, until you get your eye to analyze the shapes automatically and your mind to plan the steps needed to achieve success in the final results.

Next, try this approach with two colors, and gradually work your way up to using numerous hues. Work with photographs for reference so you can do these exercises in the studio.

One way to develop your skills in working with negatives is to use a liquid latex mask to cover areas you want to protect from paint you apply around them. With more and more practice you should gradually use less and less masking fluid, even in complex paintings. You should always endeavor to use liquid latex as an aid, not as a crutch; that way you will push yourself to achieve a higher skill plateau. In the following demonstration I will show you some of the advantages masking fluid offers, especially when you are composing a fairly intricate image. A painting like this one—*Fiddlehead Hill*—could be done in a dodging method, but you might lose your sanity. The alternative is basically to apply the liquid latex (I recommend Tranzmask) on top of each wash that needs protection as you progress from lights to darks. The important factor with this technique is to let each wash and mask application dry completely before you proceed with the next step. Apply the washes in a juicy fashion, always flowing them on to prevent opacity. It's also necessary to use a stronger color than normal, as a slight amount comes off with the mask you remove.

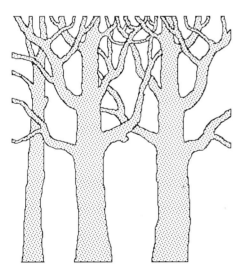

POSITIVE IMAGE

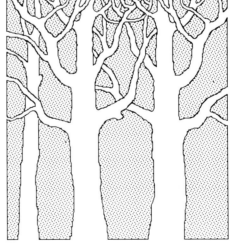

NEGATIVE IMAGE

Try to see your subject in terms of the shapes that surround it, as this illustration of trees shows. Handling negatives is a little like working a jigsaw puzzle. The more shapes you get in place, the more the image they form starts to materialize.

I define the small flowers at the bottom of the painting with liquid latex tinted with burnt sienna.

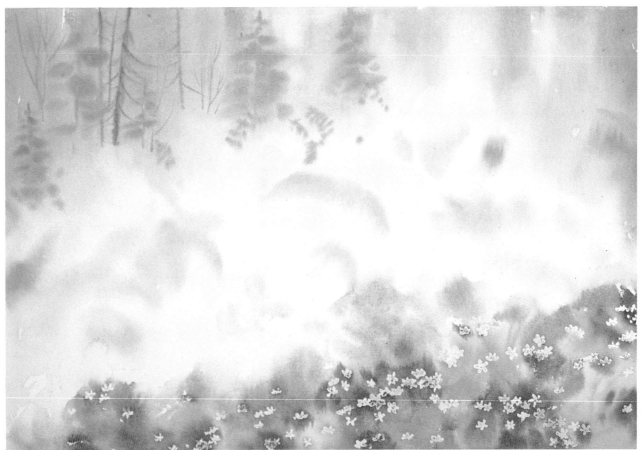

On satin-wet paper I put down a wet-in-wet wash with a 2" hake brush using both of the yellows on my palette and introducing a little Antwerp blue to establish greens in the fern area. At the bottom of the fern area are bold touches of cerulean blue, providing a granular texture for the rocks. Moving to the top background area, where the paper is becoming mat wet, I render the sky and trees with a ¾" nylon bright brush, using the blues on my palette and a touch of new gamboge for the greens. Then with the same brush I give importance to the little flowers along the bottom with a medium-dark wash, varying its hue from Antwerp blue and new gamboge for the greens to burnt sienna for the earth color and ultramarine blue for the darker sections.

Here I randomly define numerous ferns with liquid latex and a #5 nylon round brush. The mask covers and protects the light yellows and greens of the first wash.

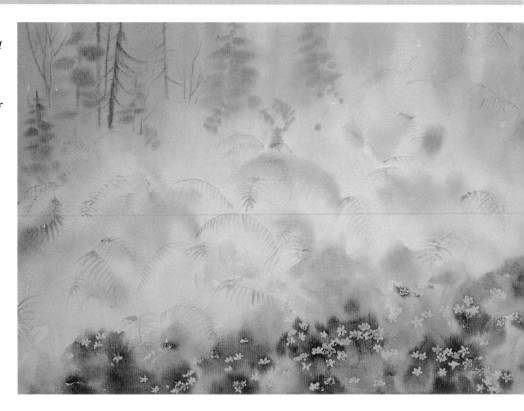

I allow the liquid latex to dry and then apply a second wash of the medium-light values of yellows and greens.

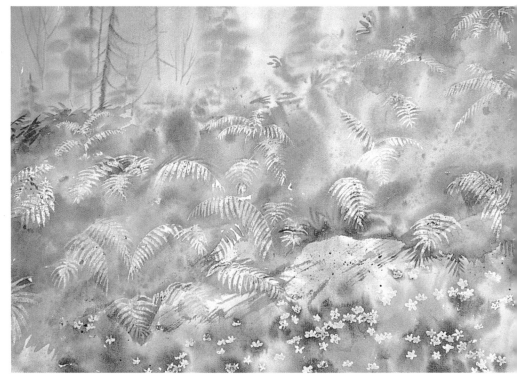

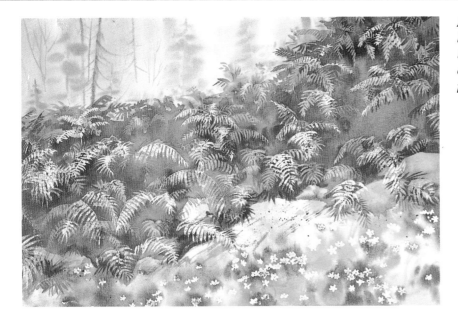

Next, I define more ferns with liquid latex, let the resist dry, and add a third wash of medium-green values, allowing this, too, to dry before proceeding.

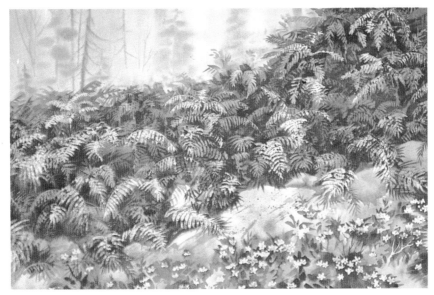

In the small spaces remaining in the fern area, I add a few more fronds with the liquid latex, then apply a fourth wash, a medium-dark value of warm and cool greens. At this stage I also define the foreground. When these washes are dry, I put down the final darks—positive forms of twigs and ferns. Now I'm ready to remove all of the latex mask; I simply lift it off with masking tape.

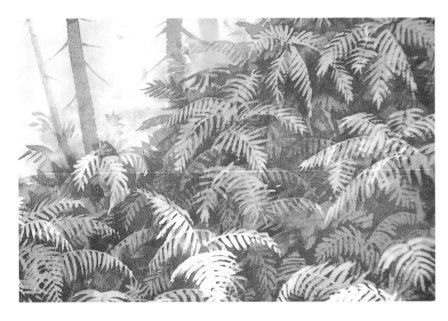

Once the mask is removed I can apply a subtle blue glaze of ultramarine and Antwerp to the ferns in the top right-hand corner of the painting, where the original yellows seemed too bright. Blueing this area causes it to recede, reducing its importance.

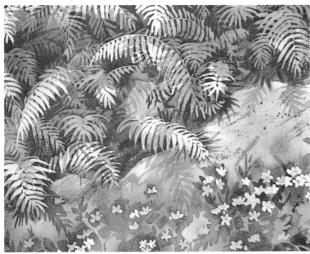

The cast shadows on the ferns and across the rocks are defined with a #8 round brush and ultramarine blue. The final touches, apparent in the completed painting, right, are a few hard-line trees in the background and a soft tint of Antwerp blue on the small white flowers in the foreground.

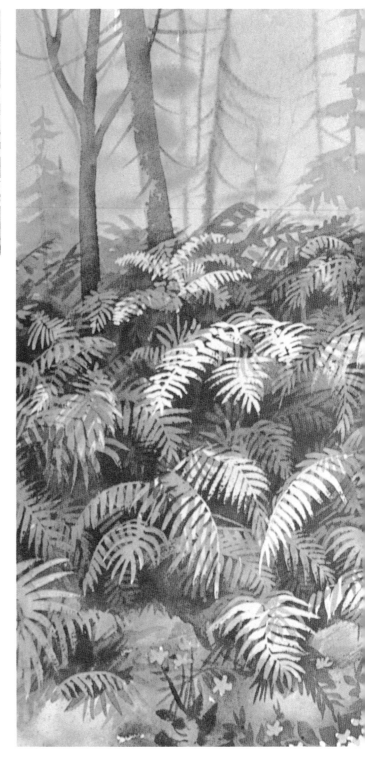

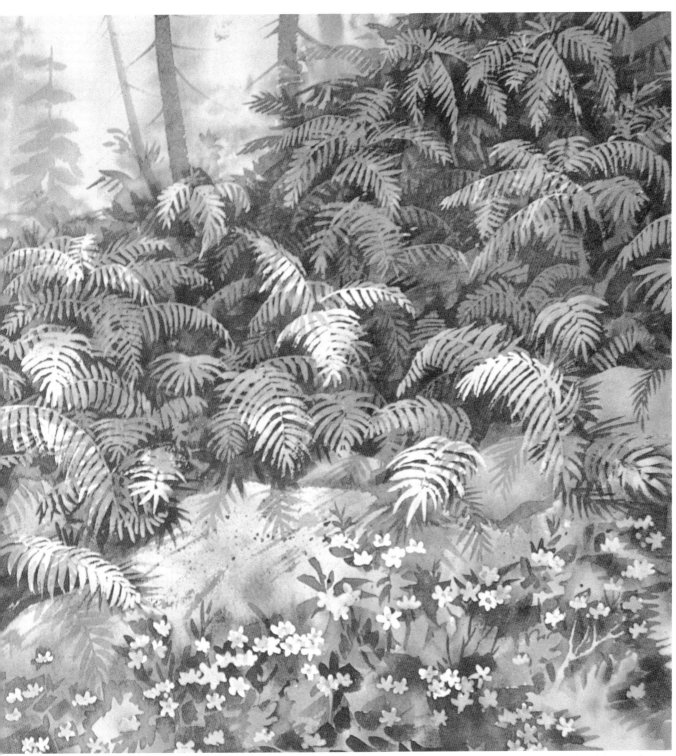

FIDDLEHEAD HILL, 18″ × 22″ (45.7 cm × 55.9 cm), Arches 300-lb. cold-pressed paper

PAINTING NEGATIVE SHAPES
THAT GRAY AREA

In the "naturescape" (a term I coined for medium-range and close-up paintings of nature subjects) *November Embers*, I used lamp black to develop the forest, and created the pattern of trees with five washes of gray, increasing the color's intensity and making the tree shapes smaller as they recede deeper into the background. Before starting the painting, I softly indicated the three dominant trees with an HB pencil. All the other trees I rendered with my brush and painted as negative shapes without the aid of masking fluid.

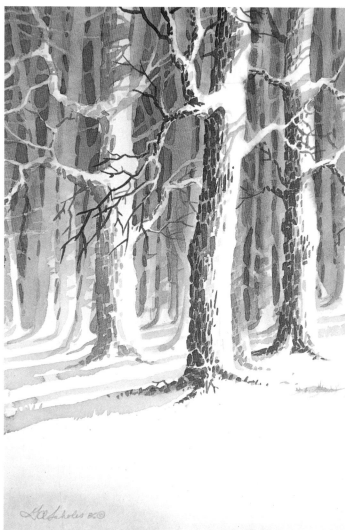

After about a year of thought and working on gaining control of painting negative shapes, I did this rough value sketch.

The idea for this painting came to me when I happened upon a very young maple bush.

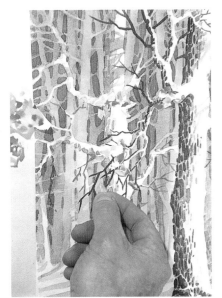

To determine the approximate position of the leaves, I place pieces of colored paper on the sketch until I come up with a pleasing pattern.

Using the colored paper leaves as a guide, I begin my painting by rendering the maple foliage. When these areas are dry, I protect them with liquid latex. The first gray value wash goes down wet-in-wet. I leave the three main trees and some large branches white and let the wash dry thoroughly.

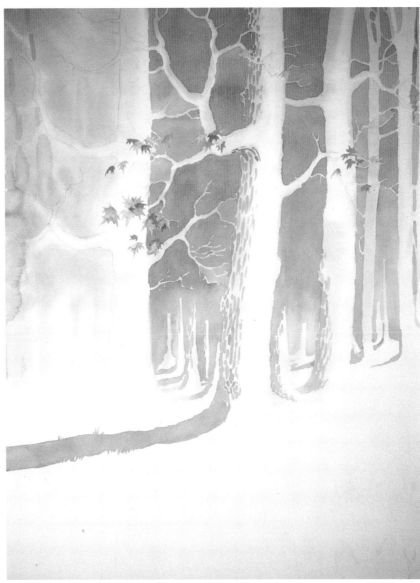

Before starting the next wash you can pencil in more trees as an aid. I choose not to, however, and proceed instead to apply the second wash of a medium-light value, working across the painting from right to left. The right side shows how I dodged around a few distant trees and branches, leaving some whites and lights of the first wash. The section to the left shows the first wash.

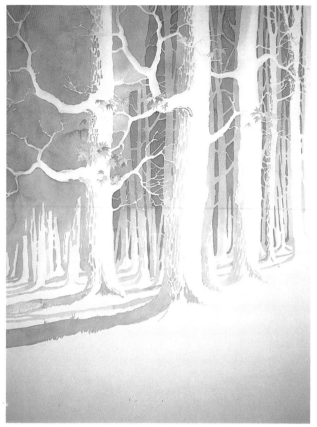

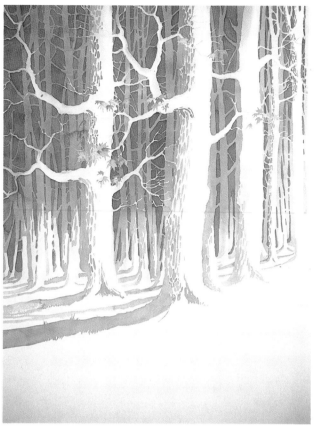

The left side now has the medium-light value in place. The right side shows the third wash in progress, where I am creating more trees deeper in the forest. This gray mix is the same value used in the second wash. Applying it over the existing layer results in the darker value required. I had to lay down this and subsequent washes carefully so as not to disturb the previous ones and cause muddiness.

Dodging the previously established trees and branches, I add a fourth wash of darker values, creating more trees.

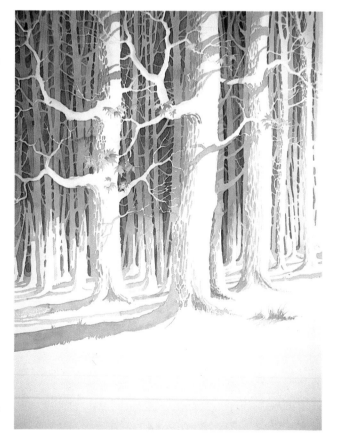

The negative shapes of the forest are now completed. In the last stage, as the finished painting shows, I further define the three foreground trees with a medium to dark value as required. Notice that the tree closest to the foreground has the strongest darks. At this point I remove the liquid latex mask from the leaves and finish the painting with a graduated wash along the bottom edge. I made a limited-edition lithograph of this painting and hand-painted the colored leaves on each print.

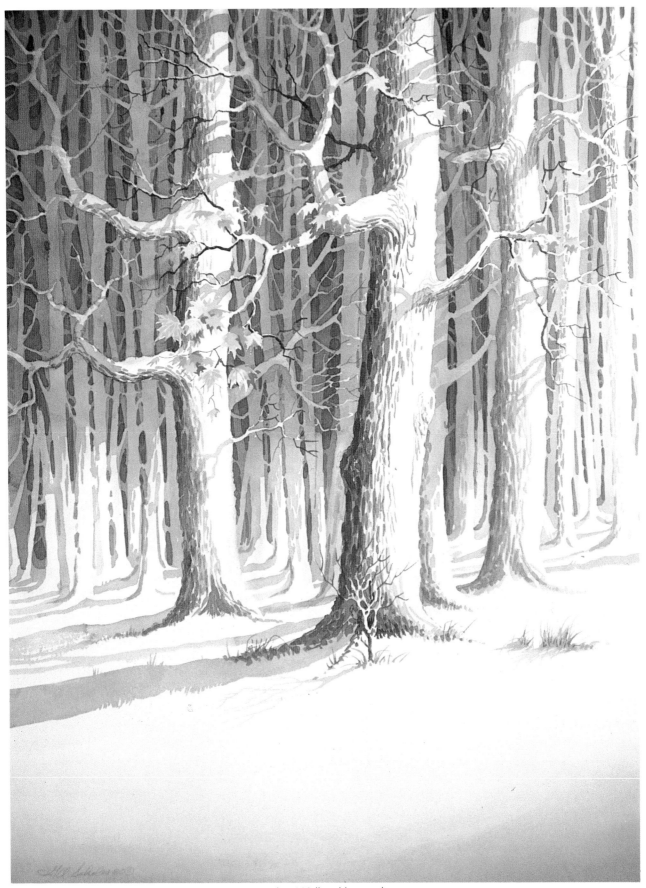

NOVEMBER EMBERS, 22" × 30" (55.9 cm × 76.2 cm), Arches 300-lb. cold-pressed paper

NEGATIVES WITH MULTICOLOR

After painting *November Embers*, I wanted to create a composition of negative shapes with the use of numerous colors. The naturescape *Come On Summer* is something from my imagination. I developed the negative shapes in the forest without pencil guidelines or liquid latex masking.

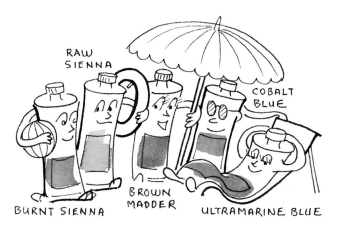

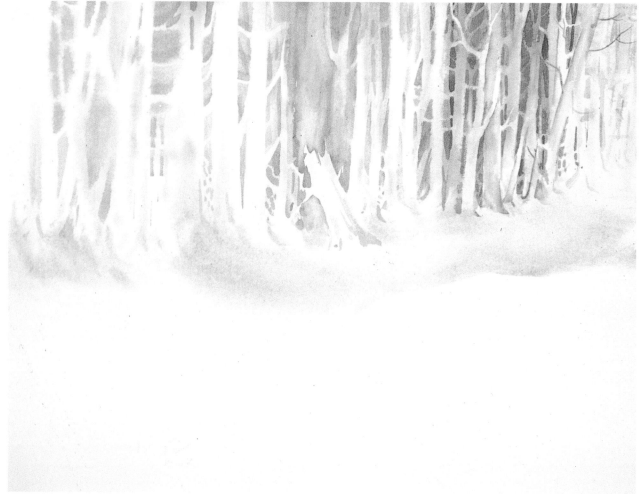

The first wash of light values goes down wet-in-wet and consists of warm colors: raw sienna, burnt sienna, and brown madder, with accents of cobalt blue in the forest area. I spot-dry sections below the forest with a hair dryer and apply a medium-light value of cobalt blue and ultramarine blue; this results in a combination of hard and soft edges at the base of the tree trunks. Then, starting at the right side of the painting and working leftward, I develop negative tree shapes using a medium-value mix of the three warm brown colors mentioned previously plus cobalt blue, allowing some of the wet-in-wet areas on each outside edge to survive.

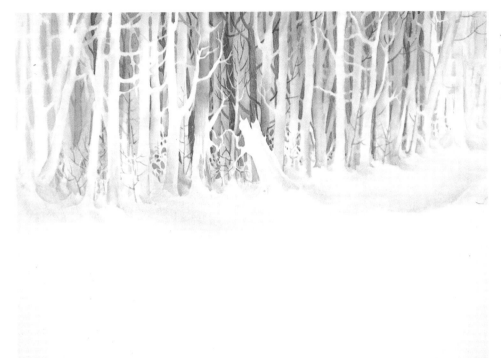

When the paper is dry, I start from the right side again, this time with a medium-dark value of the same pigments, mixing cooler, darker colors for more negative and positive tree shapes within the forest.

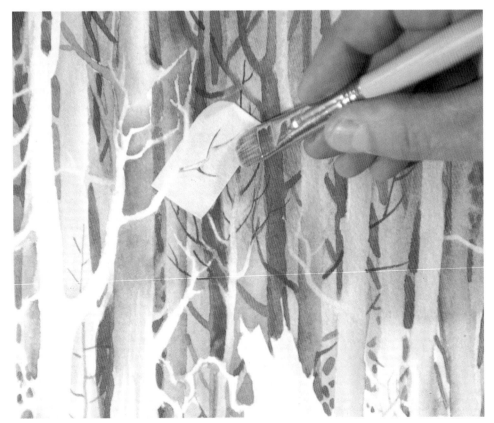

To define some small branch structures in the forest, I make a masking tape template with a sharp utility knife and place it on the painting surface. Using a damp bristle brush, I gently scrub the paper to lift out color for these details.

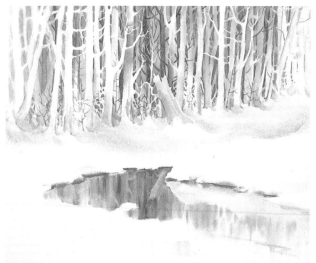

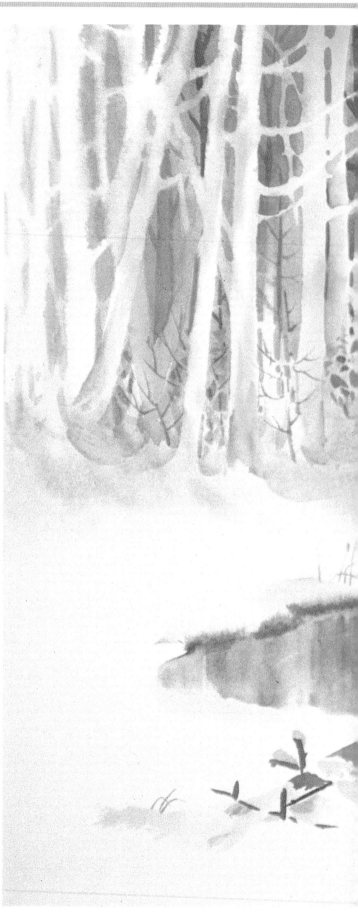

I define the pool shape with ultramarine blue, the value you see here in the reflected snowbank. The dark edge where the snowbank meets the pool is a strong accent of ultramarine blue touched with burnt sienna in a few places. For the reflection on the pool I use the same warm colors of the forest, applying them in a wet-in-wet technique. Washing them over the ultramarine blue causes the reflection to be grayer and darker.

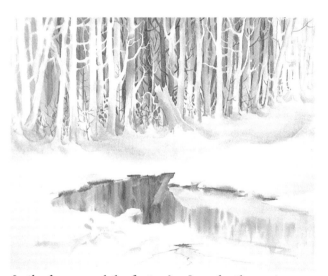

In the foreground the first value I use for the contours of snow around the diving board and rocks consists of ultramarine and cobalt blue. I render the diving board and rocks, placing a few tufts of grass in this area and elsewhere around the pond, as you can see in the finished painting at right. I see that I need another glaze of a warm color on the stump reflected in the water to reduce its importance, so I apply it, following it with a glaze of cobalt blue toward the bottom right corner of the painting where I want to define the edge of the ice. I do this very gently and quickly so as not to disturb the first wet-in-wet wash. To complement the lithograph of November Embers, I made a print edition of this painting as well, hand-painting the details of grasses and rocks around the pool.

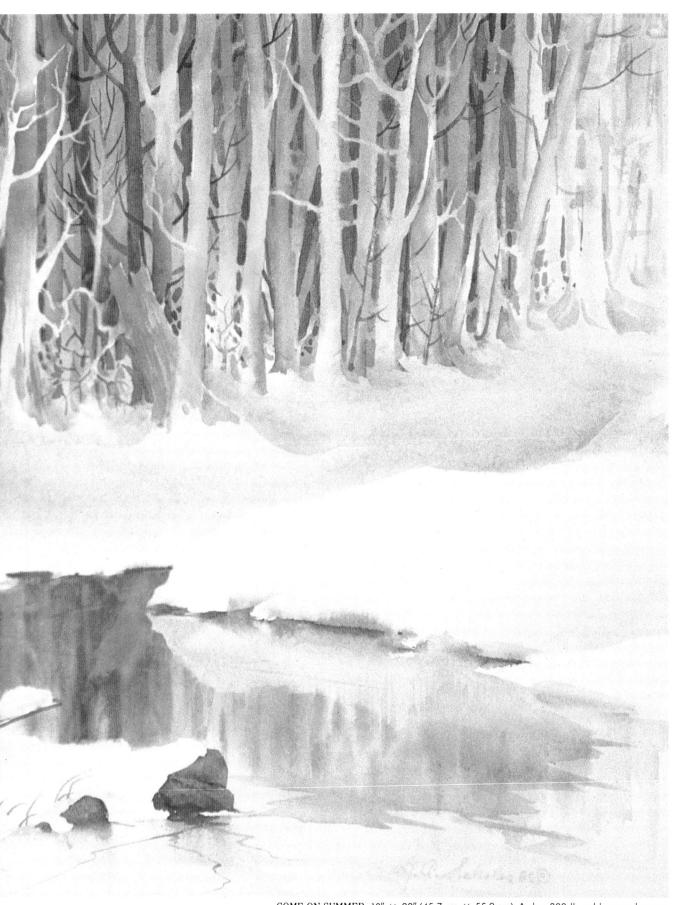

COME ON SUMMER, 18″ × 22″ (45.7 cm × 55.9 cm), Arches 300-lb. cold-pressed paper

STYLE
Getting There

Experience is the best teacher, and nothing could be more apt for an artist. Developing a style of your own involves observation, painting and sketching on location, experimentation with materials and subjects, and working your way through many, many compositions. As you follow this formula and filter it through your personality, your style will evolve.

ARRIVING AT YOUR OWN STYLE

As artists we are influenced by everything that touches our lives; everything we see and experience influences the style of our work. Ability is another important factor. Personality has a great influence as well. One of the traits of my personality is that I want to be an originator, and early in my career I discovered I had the ability to pick subjects that satisfied this desire. I recall the painter Zoltan Szabo saying to me one time on a sketching trip, "You sure have an eye for subject matter." I must say, that's about all I had at that time. As my skills developed, my style gradually changed. Confidence in working with the medium has opened new frontiers and enabled me to try different approaches to solving the design aspects of a painting. A lot of experimentation was required to realize growth and arrive at my present-day imagery. The interesting part is that my personality is still saying, "Keep going, guy. There's more out there."

Eventually I evolved a style in which I use loose realism for my main subject and abstract forms in the background or foreground. For this part of the book I have picked out a few paintings that illustrate my growth, in hopes that showing you the transition I have experienced will help you in your own search.

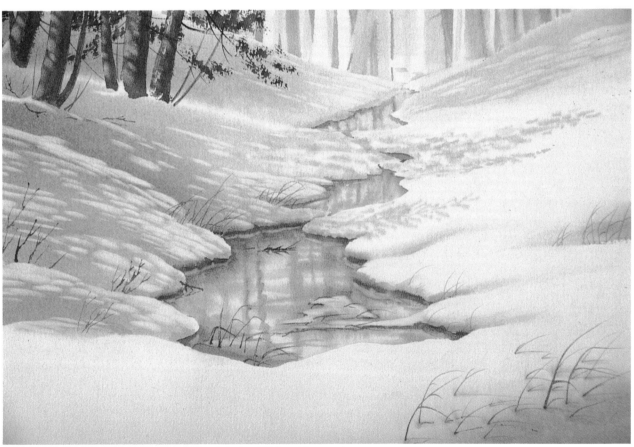

SPRING WATER, 11" × 15" (27.9 cm × 38.1 cm), Arches 140-lb. cold-pressed paper

Putting to use abstract line, space, and form in the background and reflective pool was the start of things to come.

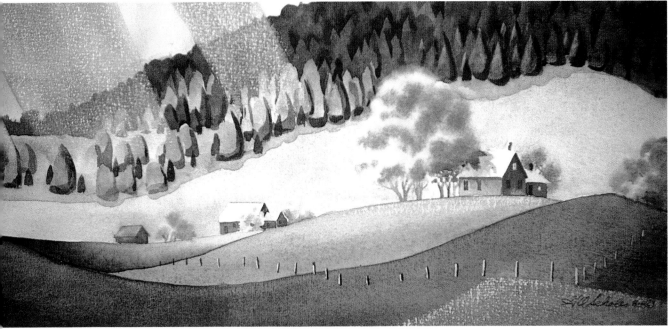

BALMORAL BEAUTY, 10″ × 22″ (25.4 cm × 55.9 cm), Arches 300-lb. cold-pressed paper

I approached this painting by working with strong colors and simple forms and space.

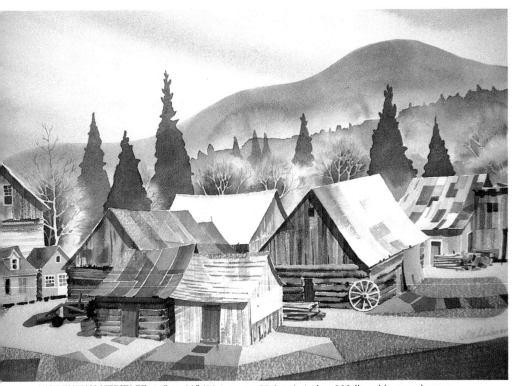

Here the abstract compositional elements have been united with some degree of realism in the buildings. The pattern formed by the unusual shapes in the roofs, doors, and sidings inspired the abstract pattern in the painting's foreground. The ghostlike transparency of these historic structures evokes the dilapidation that has overtaken them due to lack of upkeep. A year after I painted them, all these buildings were gone.

LAURENTIAN HERITAGE, 15″ × 22″ (38.1 cm × 55.9 cm), Arches 300-lb. cold-pressed paper

MY STYLE OF WORK

Many of my friends and collectors of my work have asked me why I changed my style by introducing abstract shapes and patterns. Some have even suggested that my work is not as appealing as it once was, and that this could affect sales. But if sales is what it's all about, I suppose I would still be a "sugar shack" artist—filling requests on a long waiting list for paintings of Quebec's beautiful old sugar shack. When this subject became too easy, I naturally moved on to others.

The same thing has caused me to pursue the challenge of uniting the abstract form with reality. It is a whole new learning process, one that for me represents achieving another skill plateau. Abstract forms continue to play a part in my work, but values and colors have become softer than in earlier paintings, particularly when I employ the wash-off technique, as in *Chicory Chic*.

RAW SIENNA BROWN MADDER ANTWERP BLUE CERULEAN BLUE

Some pencil work helps me position the buildings, surrounding trees, and fences. Then, using 1½" sky wash and ¾" nylon bright brushes with all the hues in the palette I have chosen, I paint the largest shapes of the buildings and background in unison, carrying color down to the fenced-in fields. I do the background in two more subtle washes, establishing the large spaces first, then coming back when this layer is dry to break up these spaces with a pattern of smaller shapes rendered with my ¾" bright brush. In the foreground I use mostly cerulean blue with some raw sienna to gradually build negative and positive floral patterns.

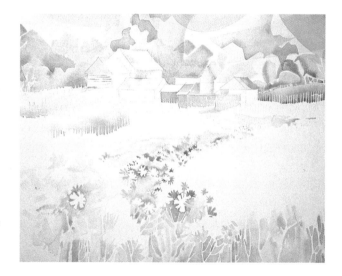

Continuing with the foreground, I add a little more definition with a ½" nylon bright brush; then the buildings are articulated in an interesting yet simple patchwork overlay of colors. I build up the background gradually with negative tree trunk and branch structures, working back and forth across the area until I am satisfied with the balance of detail and color.

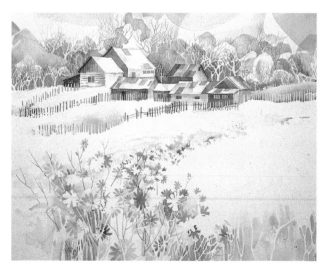

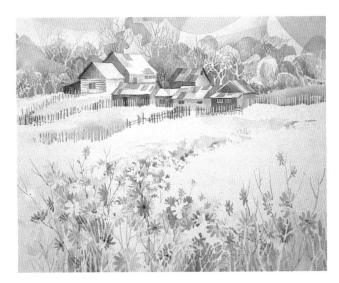

At this stage the foreground is finished, and the painting sits in my studio for several weeks.

One morning I realize the abstract patterns in the background should be carried down to the fields in front of the barns. Below, I drop in shapes to unite the background with the middle ground, and everything now seems in balance.

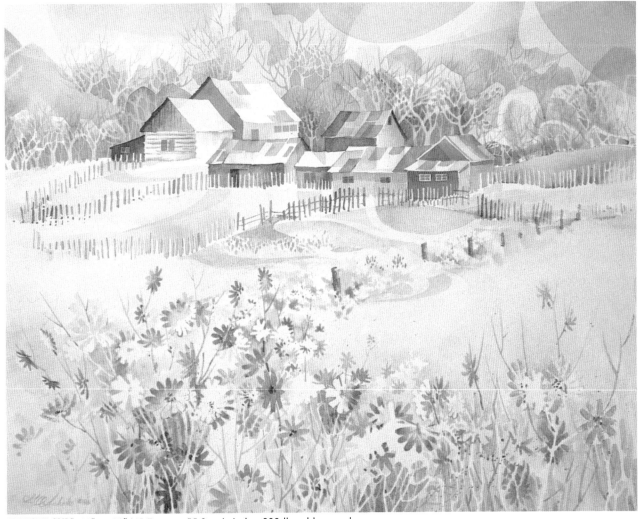

CHICORY CHIC, 18″ × 22″ (45.7 cm × 55.9 cm), Arches 300-lb. cold-pressed paper

DEVELOPING A THEME

My art school teacher Fred Fraser used to take us out on painting excursions, and most times the subjects we rendered were buildings in the form of sheds and garages we saw in back alleys. The stimulation of these trips has stayed with me, and today I have a soft spot for architectural subjects. As my skills have improved, my treatment of these subjects has grown more sophisticated. The theme for the following series of works came to me while I was photographing the building that eventually became the painting *La Pension*. This edifice was everything I envisioned a pension should be.

WORKING FROM REALITY TO FANTASY

The scene in the photograph shown here, one I came upon in a small village in Quebec's Laurentian Highlands, gave me the idea of recording old buildings. *La Pension* was the first in a series of architectural paintings in which I have depicted the buildings themselves accurately but allowed my imagination to run free in the background and foreground, where I use abstract shapes. I began this painting with a drawing of the house that was faithful to reality, then created the sky pattern.

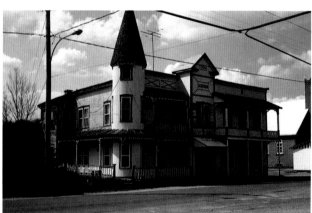

For both the sky and foreground I employed the wash-off method as described in the demonstration for the painting Monday in March *(pages 90–97). After washing off the sky for a third time, I let the area dry completely and then gave it some texture by rubbing it with #120-grade sandpaper.*

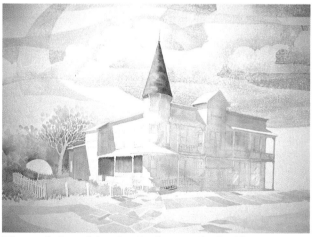

The wash I used for the shadow on the building is dominated by ultramarine blue with touches of burnt sienna and raw sienna; I applied a glaze of the same value to define the railings and similar details.

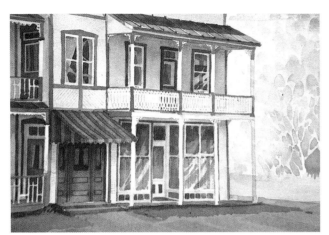

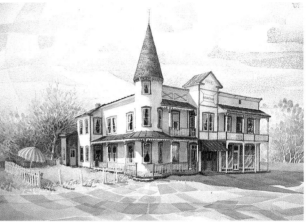

Another medium blue value was carried under the overhanging verandas, and two more values, dominated by burnt sienna, were used for the rusty roof, front door area, and back shed. No masking fluid was used.

For the tree shapes at left and right I made use of the total palette of colors I had chosen for the painting. Rendering a liberal amount of branch structure and keeping the colors pale created a springlike atmosphere.

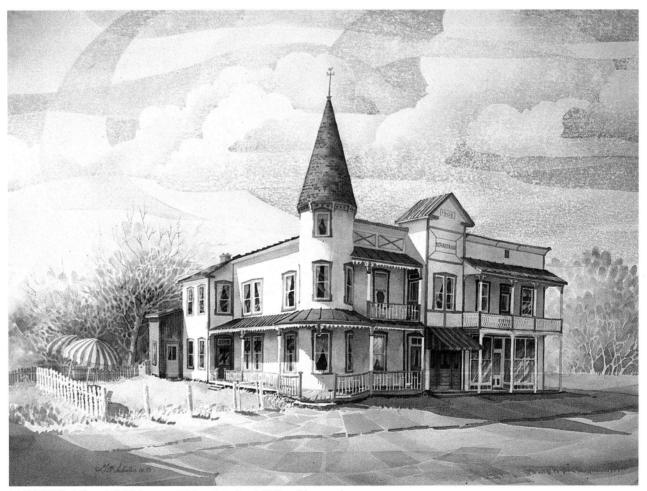

LA PENSION, 22″ × 30″ (55.9 cm × 76.2 cm), Arches 300-lb. cold-pressed paper

A final touch was a glaze of green in the foreground and a shadow in the left corner.

TRANSFORMING A SETTING

This building in St. Sauveur, Quebec, made a fitting subject for the second image in my series of paintings of pensions, or lodging houses. To make the building the focus of the composition, I wanted to eliminate the clutter of its urban setting. I gave a lot of thought to how I could accomplish this, and

discovered that some of the undesirable details, like the power lines in the photo, inspired an abstract approach—in this case, the shapes in the sky. The angle at which the photograph was shot—oblique to the street corner—provided me with a path of vision that in the painting leads the eye from the shadow at right across the foreground to the lamppost, then back to the right of the composition.

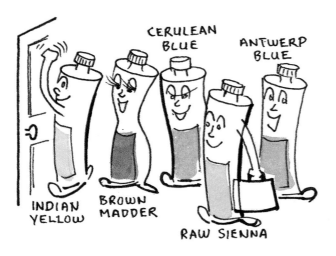

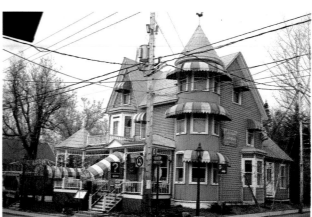

I established early morning light by applying a strong wash of raw sienna over the entire sky, background, roof, and shadow areas of the house. When this was dry, I proceeded with the same sequence of washes, glazes, and wash-offs in the sky as described for the painting Monday in March *(pages 90–97). The warm value of the awnings and windows, a mix of Indian yellow and brown madder, was applied before I rendered the rest of the building. Cerulean blue is the dominant color in the mix I used for the house itself, which included Antwerp blue and brown madder. I worked in sections, painting the turret, right side, front, veranda, and so forth in turn. I did not use latex masking, as I preferred the challenge of dodging, which also gave me a little looser quality. For the tree shapes on either side of the house I put down a series of washes with a ½" filbert brush, establishing the push-pull of lost and found edges. The branch structure was done with a ½" nylon bright brush.*

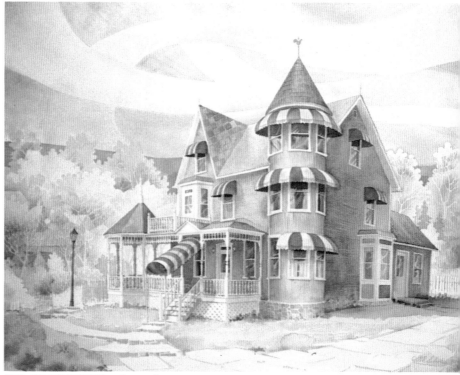

BED AND BREAKFAST, 22" × 30" (55.9 cm × 76.2 cm), Arches 300-lb. cold-pressed paper

FOCUSING ON SUBJECT MATTER

While working on my lodging series I realized that there are far more houses than names that would accurately characterize them. As I searched for another theme that would enable me to capture the wealth of these architectural subjects, I got the inspiration to do a "palate" series—images of buildings that suit food-oriented names. *English Muffin, Tea and Crumpets,* and *Cinnamon Toast* are just a few examples of where the theme has led me so far; I expect to be able to work on this series for years. I like the stimulation of finding subject matter that conjures up creative images and ideas.

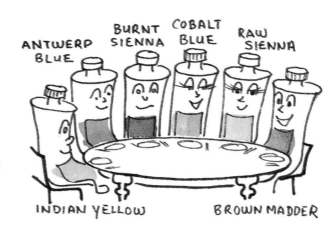

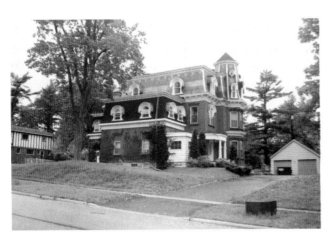

This old, Victorian-style house in Barrie, Ontario, is still standing. It has, however, lost its elegance of yesteryear. The third floor was once a grand ballroom that offered a view of the town and Lake Simcoe, a mile away. In my research I was able to locate old family snapshots from former occupants that showed the lovely ornamental work of the porch and other details that had enhanced the building's appearance in the 1930s. In composing my painting I recaptured these lost embellishments and eliminated the large trees you see in the photo, on the premise that forty years ago they would have been very small.

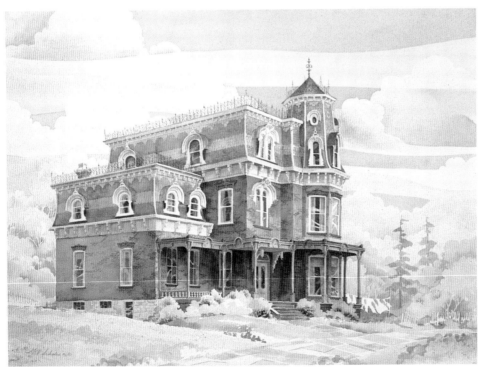

The method I followed in this painting is the same as that employed in Bed and Breakfast. *Cobalt blue was used for the shadow areas and the slate mansard roof, giving a soft tone. I was careful to maintain loose realism when indicating the bricks, using them as a pattern and path of vision in the small areas within the building. The subtle abstract shapes in the windows are compatible with the sky.*

ENGLISH MUFFIN, 22″ × 30″ (55.9 cm × 76.2 cm), Arches 300-lb. cold-pressed paper

Tea and Crumpets, *a companion piece to* Bed and Breakfast, *is the same building in St. Sauveur painted from a different viewpoint. I developed the abstract shapes in the sky gradually, using the wash-off procedure; the house and foreground were rendered in the pyramid method of establishing light, medium, and dark values.*

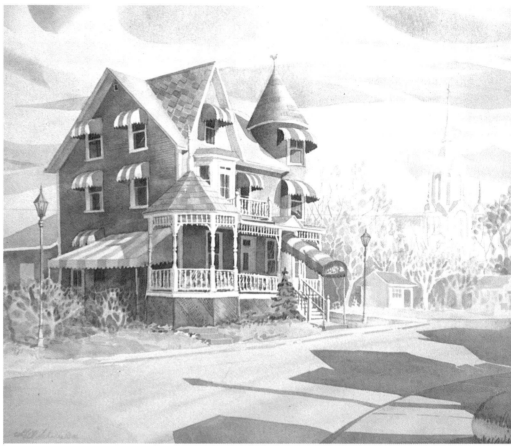

TEA AND CRUMPETS, 18″ × 22″ (45.7 cm × 55.9 cm), Arches 300-lb. cold-pressed paper

This grist mill, located in Hillsdale, Ontario, was painted according to the same procedure I followed for Tea and Crumpets.

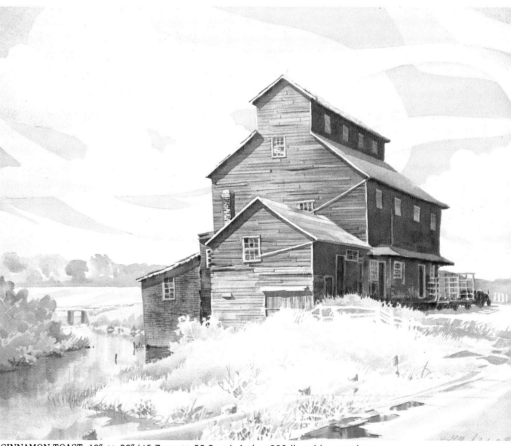

CINNAMON TOAST, 18″ × 22″ (45.7 cm × 55.9 cm), Arches 300-lb. cold-pressed paper

CAPTURING HISTORY

In most towns and cities there are ghosts—ghosts in the sense of memories and sometimes photographs of historic buildings that once stood proud. Barrie, the small town in Ontario where I lived for eight years, was no exception to the town fathers' lack of foresight and the wrecker's ball. But as an artist, I have attempted to recapture some of our lost architectural heritage through paintings.

I start this kind of project by first visiting an archives office in the area. If this fails to provide reference material, national offices can probably supply information. In this case the Public Archives Canada in Ottawa provided the photograph I sought.

Barrie's old post office and Grand Truck Railroad Station. Occasionally a building contemporary with a now-demolished subject is still standing, giving me an idea of which colors would be most appropriate for my painting.

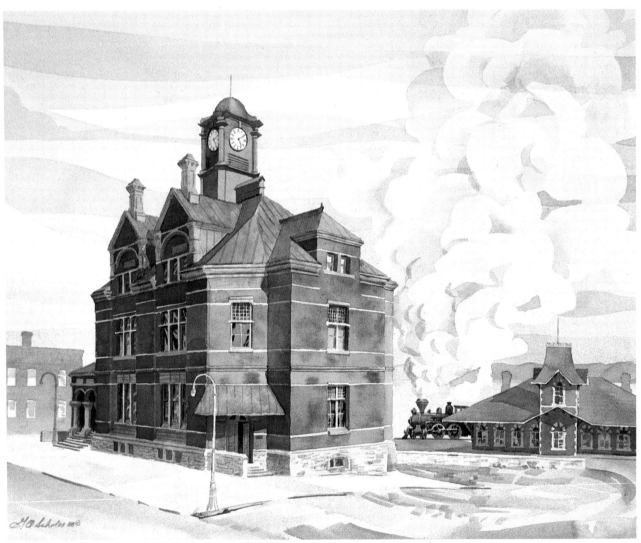

BARRIE'S HERITAGE, 18" × 22" (45.7 cm × 55.9 cm), Arches 300-lb. cold-pressed paper

BROADENING YOUR HORIZONS

When you reach a plateau in your artistic skills, be it an achievement in drawing ability, mastering a particular technique, or capturing a subject that eluded you in the past, you may be temporarily satisfied and remain at this level for a while. Sometimes you may even regress for short periods before moving on to the next challenge. But the object is to keep growing.

MEETING A CHALLENGE

It took a while before I tackled floral subjects using the combined abstract and realistic style I had evolved in other paintings. *Easter Bouquet* was a departure for me, because hard-line abstract detailing in the background had to be handled very carefully so as to complement the floral arrangement yet not draw too much attention away from it. This composition was painted without the use of masking fluid; I washed off the background several times before I rendered the details of the blossoms.

EASTER BOUQUET, 12″ × 22″ (30.5 cm × 55.9 cm), Arches 300-lb. cold-pressed paper

CREATING A DIPTYCH

I like to paint diptychs because they add a little sparkle to an exhibition and are excellent for wide, panoramic subjects. You don't simply make one painting and cut it in half; instead, you create two images on separate sheets of paper and pair them.

The reference material I prefer is a pencil sketch of two scenes, or two panoramic landscape photographs. Each panel of the diptych must be able to stand alone as a separate painting with good composition and design. You can mount both panels in one frame with a specially cut mat, or frame them individually and hang them side by side.

TO THE LAURENTIANS, each image 11″ × 7½″ (27.9 cm × 19.1 cm), Arches 300-lb. cold-pressed paper

BREAKING BOUNDARIES

This painting was commissioned by the Barrie Huronia Balloon Association for its annual Fantasy Festival. I arrived at its design after several months of thought and numerous thumbnail roughs. In my initial sketches, color totally enclosed the balloons, and the border seemed to constrain them. One day I drew an inner border on one of the sketches, and suddenly the balloons had the space they needed to float freely—truly expressing buoyancy.

When the painting was finished, the composition looked somewhat off balance. I added the distant balloon that floats between the clouds beyond the left border, and that solved the problem. To see for yourself how even a minor element can affect a composition, place a small piece of white paper over this distant balloon.

FANTASY FESTIVAL, 30" × 22" (76.2 cm × 55.9 cm), Arches 300-lb. cold-pressed paper

SELECT BIBLIOGRAPHY

Edwards, Betty. *Drawing on the Right Side of the Brain*. Los Angeles: J. P. Tarcher, 1979.

Kautzky, Ted. *Painting Trees and Landscapes in Watercolor*. New York: Van Nostrand Reinhold, 1952.

———. *Ways with Watercolor*. New York: Van Nostrand Reinhold, 1953.

Nicolaides, Kimon. *The Natural Way to Draw*. Boston: Houghton Mifflin, 1941.

O'Hara, Eliot. *Making Watercolor Behave*. New York: Minton, Balch, 1932.

———. *Watercolor with O'Hara*. New York: G. P. Putnam's Sons, 1966.

Pike, John. *John Pike Paints Watercolors*. New York: Watson-Guptill, 1978.

———. *Watercolor*. New York: Watson-Guptill, 1966.

Reid, Charles. *Figure Painting in Watercolor*. New York: Watson-Guptill, 1972.

———. *Flower Painting in Watercolor*. New York: Watson-Guptill, 1979.

Shapiro, Irving. *How to Make a Painting*. New York: Watson-Guptill, 1985.

Szabo, Zoltan. *Landscape Painting in Watercolor*. New York: Watson-Guptill, 1971.

———. *Painting Nature's Hidden Treasures*. New York: Watson-Guptill, 1982.

———. *Zoltan Szabo Paints Landscapes*. New York: Watson-Guptill, 1977.

INDEX

Arches paper, 30
Architectural subjects
 abstract/realistic, 132–33
 historic, 137
 imagery of, 135–36
 setting for, 134
Atmospheric perspective, 44

Background
 abstract shapes in, 128, 129, 130,
 131
 integrating subject with, 68
Blue, manganese, 26, 76, 77
Brushes
 holding, 16–17
 for latex masks, 21
 moisture control, 29, 54
 selecting, 14
 types of, 15
Buckling problem, eliminating, 31

Camera, 32
Colors. *See* Paints
Composition, 34–51
 balanced, 38–39, 141
 changing nature, 36–37
 direction in, 40
 faults in, 42
 overworking, 43
 perspective in, 44–45
 weight in, 41
 See also Sketches/sketching

Debossing, 50–51
Diptych, 140
Drybrush technique, 16, 57, 60, 87,
 101–9

Easel, 12
Easel-Mate, 12, 13
Equipment and materials, 10–33
 brushes, 14–15
 on-location, 12–13
 painting tools, 18–21
 paper, 30
 photographic, 32
 sketching, 46, 50
 See also Paints
Eraser, 19

Floral subjects, 138
Fraser, Fred, 12, 29, 132

Knife, painting, 18

Landscapes, masking in, 64–65
Latex masks. *See* Masking fluid
Linear perspective, 45
Lines, in composition, 38, 39

Masking, 21, 60–65, 112–17
Masking fluid, 21, 60, 112–17
Masking tape, 19, 31, 60, 64, 85, 86,
 87, 123
Materials. *See* Equipment and
 materials
Mounting board, 31

Negative shapes, 20, 110–25
 debossing, 50–51
 with masking fluid, 112–17
 multicolor, 122–25
 painting, 118–21

O'Hara, Eliot, 14

Paints
 mixing, 27, 29, 76
 money-saving tips, 29
 palette, 24–28
 selection criteria, 22–23
 undesirable pigments, 28
Palette, 24–28
Paper
 selecting, 30
 washes, 31
 wetness of, 54
Pen, dry, 18
Perspective, 44–45
Photographs
 as reference material, 32
 of work, 33
Plexiglas overlay, 71, 74
Poly brush, 18
Pyle, Howard, 9
Pyramid technique, 58–59

Razor blade, 19
Reflections on water, 81, 98–99, 124
Run-back technique, 55, 56

Salt, 20
Sandpaper, 19
Sepia technique, 26, 84–89
Setting, transforming, 134

Sketches/sketching
 debossing, 50–51
 thumbnails, 47
 tools, 46, 50
 value, 48–49
Sponge, 20
Staining
 quality of pigments, 22, 23, 70
 technique, 70–75
Style, 126–41
 abstract/realistic, 128–31, 138–39
 broadening, 138–41
 theme development and, 132–37
Szabo, Zoltan, 18, 43, 128

Technique, 52–109
 drybrush, 16, 57, 60, 87, 101–9
 masking, 60–65
 for moving water, 100–109
 nonstaining, 76–83
 painting in sections, 66–69
 pyramid, 58–59
 for reflections on water, 98–99,
 124
 run-back, 55, 56
 sepia, 26, 84–87
 staining, 70–75
 wash-off, 90–97, 130, 131, 132
 wet-in-wet, 31, 54, 56, 65, 122
 See also Negative shapes
Texture
 drybrush technique for, 57
 masking for, 60–63
 of pigment, 22, 23
 painting tools for, 20
 of paper, 30
Theme, developing, 132–36
Transparency of pigment, 22, 23

Value sketches, 48–49

Washes, 31
 pyramid of, 58–59
Wash-off technique, 90–97, 130, 131,
 132
Water
 moving, 100–109
 reflections on, 81, 98–99, 124
Wax paper, 20
Wax stick, 21
Wet-in-wet technique, 31, 54, 56, 65,
 122, 124

SUGAR SHACK NEAR ST. JANVIÈR, QUEBEC